GLACIER

a photographic journey

photography and text by
Zack Clothier and Stephen C. Hinch

FARCOUNTRY
PRESS

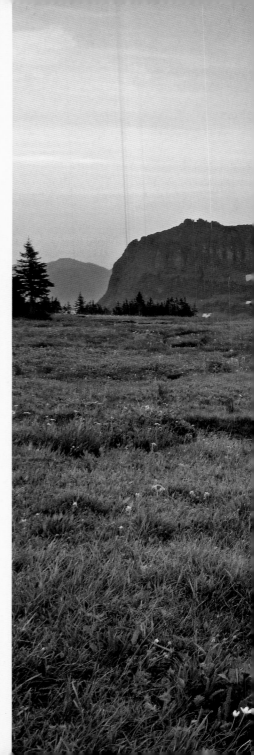

For my wife, Cortney. For your love, support, and most of all your patience.

—Zack Clothier

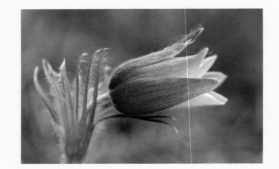

For the two amazing people in my life, my wife Edyta and my daughter Sophie. Thank you for your love and support.

—Stephen C. Hinch

Above: Pasque flowers are one of the first wildflowers to bloom each spring. Common in lower elevations, they can grow in a variety of habitats but seem to be prevalent in pine forests. Because they bloom early, they're often associated with Easter, hence the name "pasque" or "passover." STEPHEN C. HINCH

Right: A small stream runs under the trail to Hidden Lake, supplying this year-round pond. In the background Reynolds Mountain basks in the first hues of red at sunrise. The hike to Hidden Lake Overlook is one of the most popular trails in the park, but those who can manage the steep hike to the lake itself are rewarded with breathtaking views. STEPHEN C. HINCH

Title page: A trail ride is an excellent way to explore Glacier's backcountry. Several outfitters in the area offer guided trail rides at Apgar, Lake McDonald, and the Many Glacier area. Cracker Lake, pictured here, is a popular destination for those seeking a true wilderness experience. ZACK CLOTHIER

Front cover: A classic view of Grinnell Lake and Mount Gould from the Grinnell Glacier Trail, one of the most popular hikes in the park. Established as a national park in 1910, Glacier is known for its world-class scenery and extensive network of hiking trails. ZACK CLOTHIER

Back cover: Simply walking outside the Many Glacier Hotel affords one of the most beautiful views in North America as Grinnell Point rises dramatically over Swiftcurrent Lake. At just over 7,600 feet, Grinnell Point is a sub-peak of Mount Grinnell, which isn't visible from the roads in the Many Glacier area. STEPHEN C. HINCH

ISBN: 978-1-56037-740-5

© 2019 by Farcountry Press

Photography © 2019 by Zack Clothier and Stephen C. Hinch.
Text by Zack Clothier and Stephen C. Hinch.

For more information about our books, write Farcountry Press, P.O. Box 5630, Helena, MT 59604; call (800) 821-3874; or visit www.farcountrypress.com.

 Produced and printed in the United States of America.

23 22 21 20 19 1 2 3 4 5 6

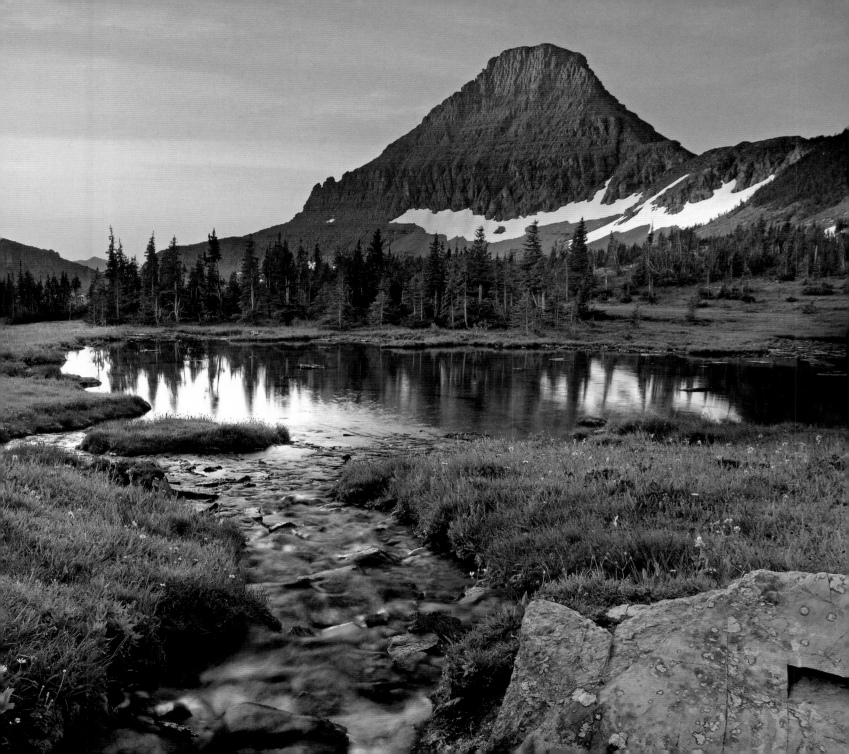

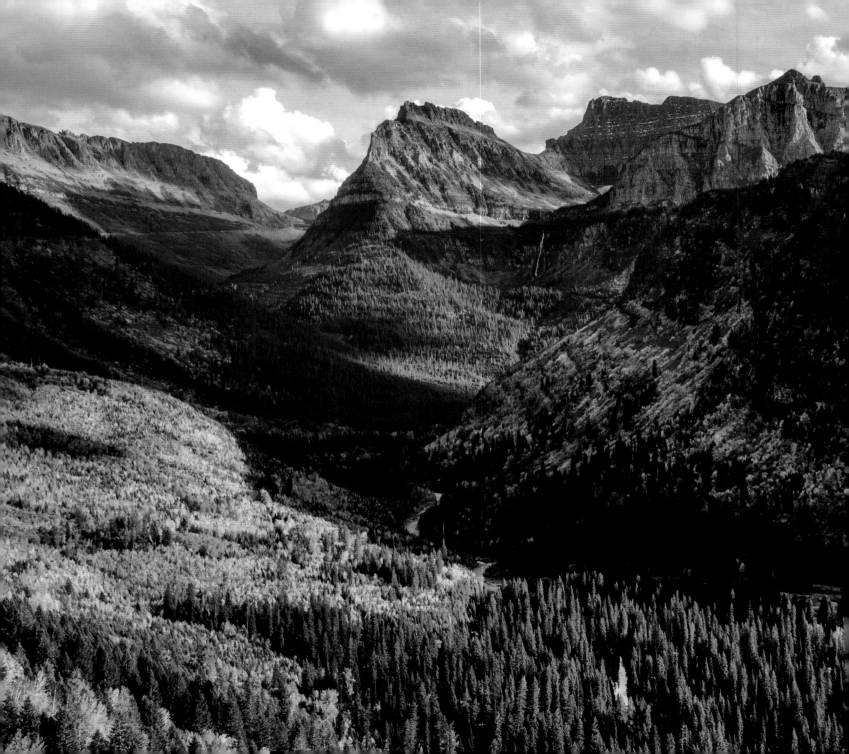

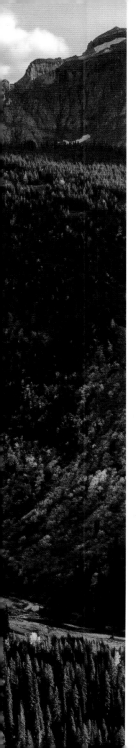

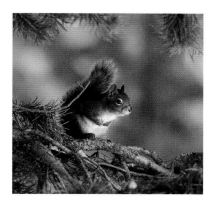

Left: Red squirrels are common inhabitants of the pine forests of the northern Rockies, and their aggressive chattering often gives them away before they're seen. Pine nuts are their primary source of food, and the diligent hiker may notice huge middens where a red squirrel has stashed away pinecones for later consumption. STEPHEN C. HINCH

Far left: One of America's finest scenic drives, Going-to-the-Sun Road was completed in 1932. About fifty miles in length, the road winds through the mountains and crosses the Continental Divide as it cuts through the heart of the park. Along the way, visitors are treated to some of the most spectacular vistas in the world, including this one of the McDonald Creek Valley on the park's west side. ZACK CLOTHIER

Below: The famous Red Buses of Glacier offer visitors the chance to explore the park in a historical way. Glacier's iconic fleet of Red Buses dates back to the mid-1930s and is widely considered to be the oldest fleet of touring vehicles in the world. ZACK CLOTHIER

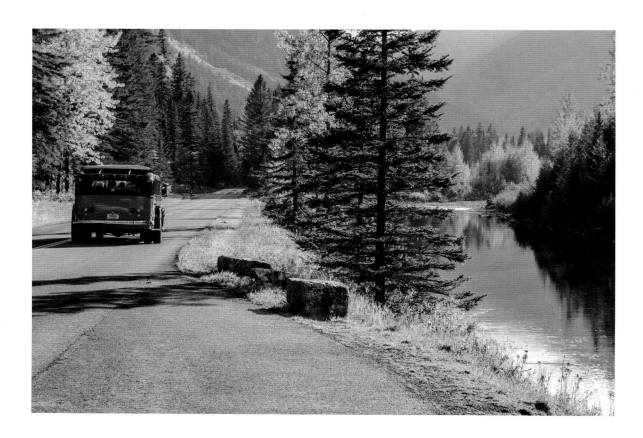

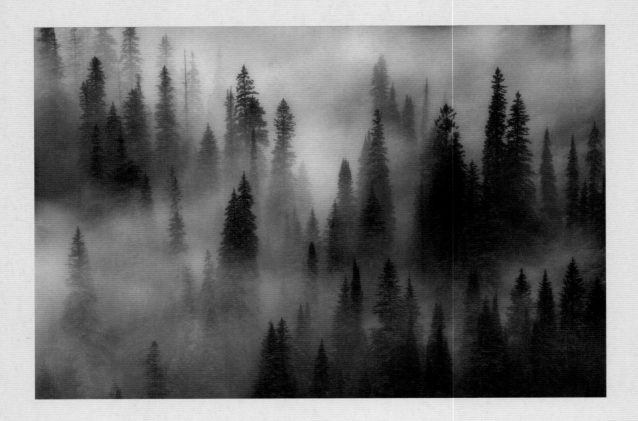

Above: Heavy fog drifts through thick timber. Over 50 percent of Glacier is forested, and these verdant forests are constantly changing. Natural processes such as fire, wind, disease, avalanches, and changes in climate are all factors behind the shaping of our forests. ZACK CLOTHIER

Right: From gentle riffles to raging currents, the streams and rivers of Glacier run clear and cold. With extremely low levels of pollutants, the park boasts some of the cleanest water in the state of Montana. ZACK CLOTHIER

Far right: Stars shine brightly in the night sky above Lake McDonald. In winter, substantial amounts of snow blanket the region, providing recreational opportunities such as cross-country skiing and snowshoeing. ZACK CLOTHIER

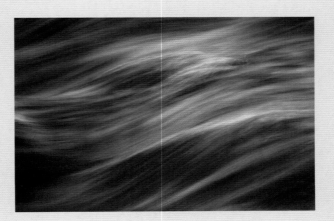

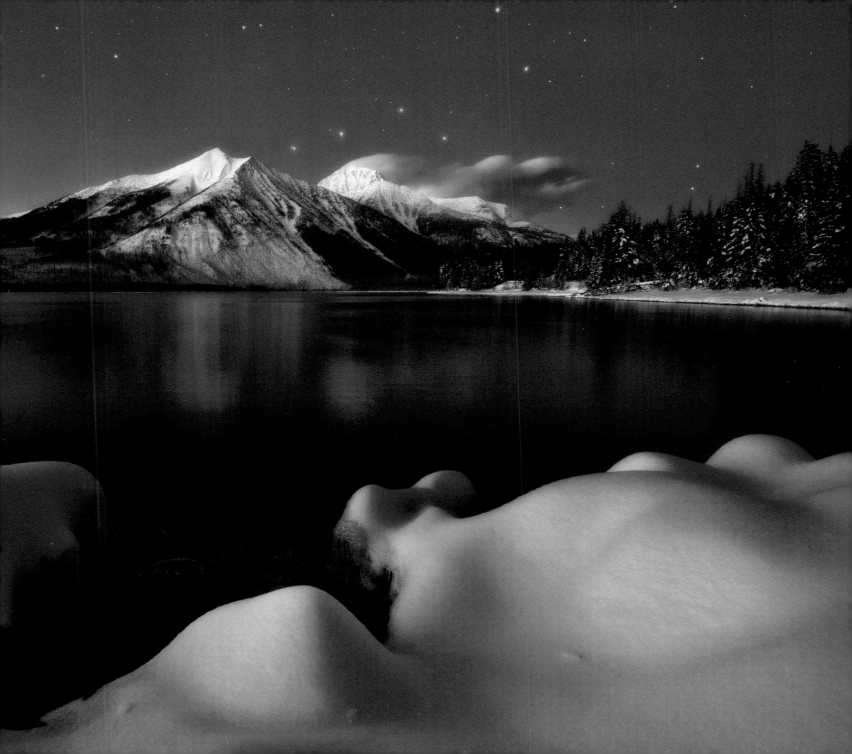

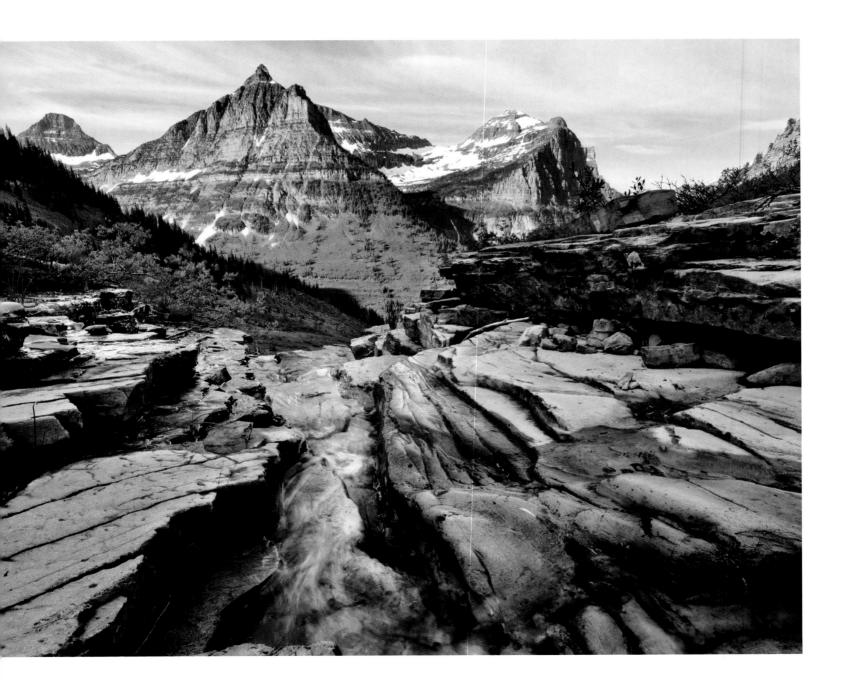

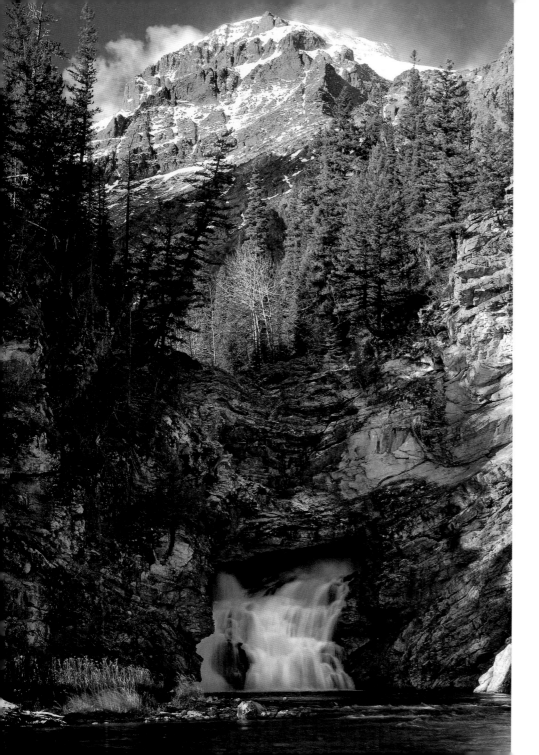

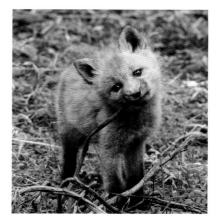

Above: Red foxes range widely throughout the United States and inhabit many national parks, including Glacier. The young, born from March through May, are playful and curious. This youngster was chewing on a stick while exploring outside the den. ZACK CLOTHIER

Left: Running Eagle Falls can be seen after a short, flat hike of only about three-tenths of a mile. It's unique because during high runoff in spring and early summer, water flows over the top, 40 feet above, obscuring the bottom falls. But when the spring melt-off is over, only the lower falls is visible as it emerges from a hole in the cliff face. STEPHEN C. HINCH

Far left: From left to right, Reynolds Mountain, Mount Oberlin, and Mount Cannon rise above a seasonal mountain stream. Views such as this one are common on the drive along the famed Going-to-the-Sun Road. ZACK CLOTHIER

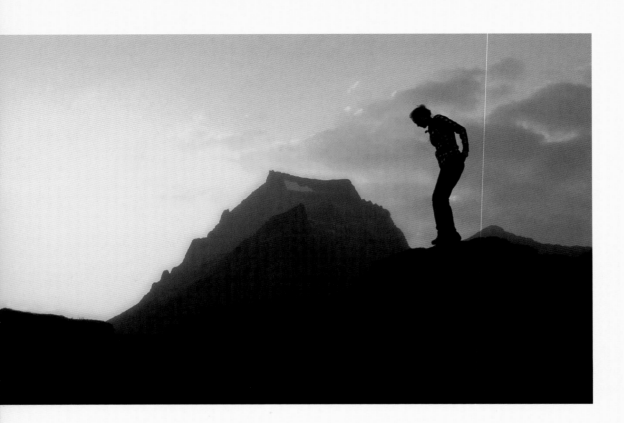

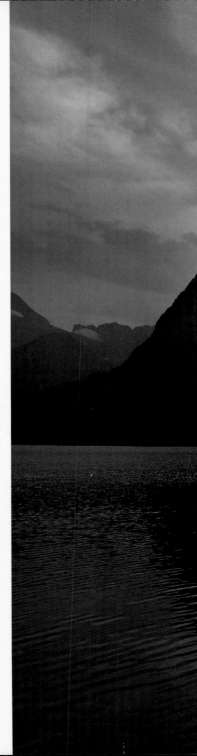

Above: At sunset, a hiker scrambles over rocks near Sun Point along the Going-to-the-Sun Road. In the background, Going-to-the-Sun Mountain dominates the view. STEPHEN C. HINCH

Right: The short-tailed weasel is the smallest mustelid in Glacier National Park, but it's still a fierce hunter, able to take down prey several times its size. In the winter their coats turn almost all white and they are called ermines. STEPHEN C. HINCH

Far right: Grinnell Point and Mount Wilbur rise dramatically behind Swiftcurrent Lake. During summer months, when Many Glacier Hotel is open, scenic boat rides are offered on the lake. STEPHEN C. HINCH

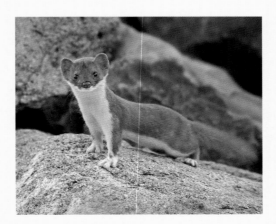

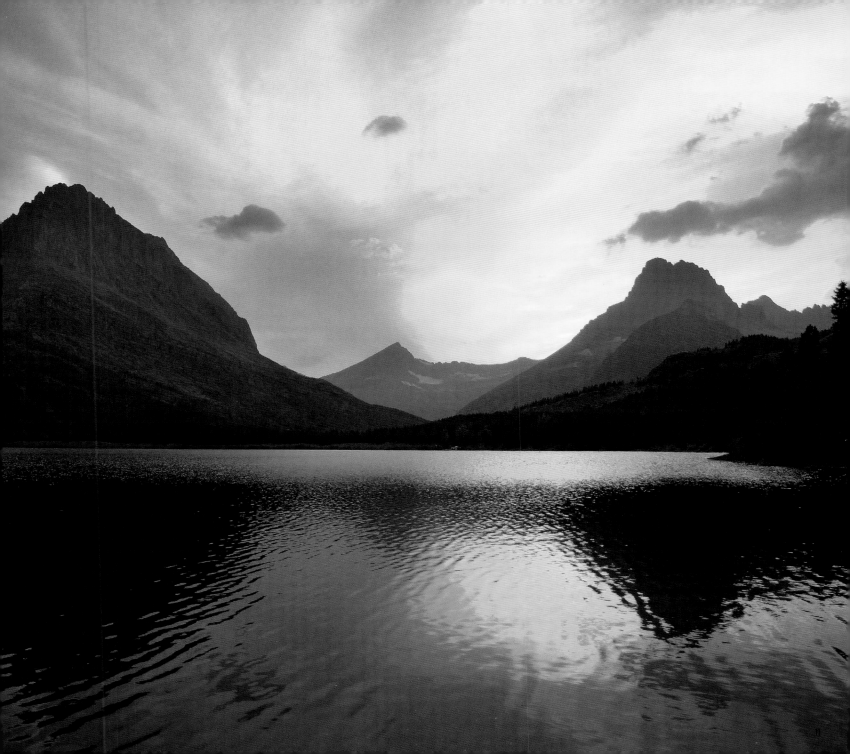

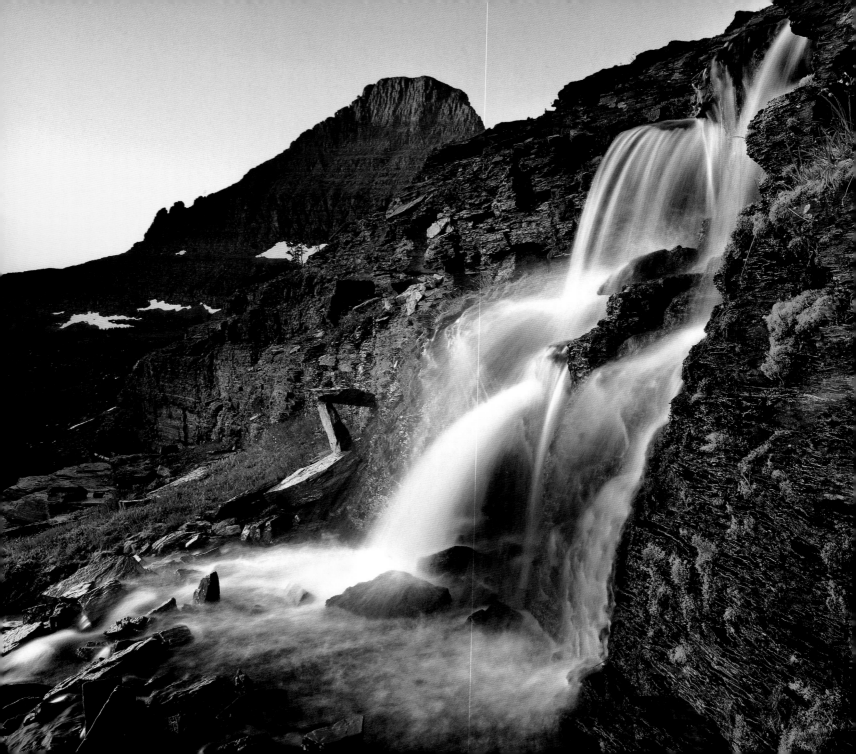

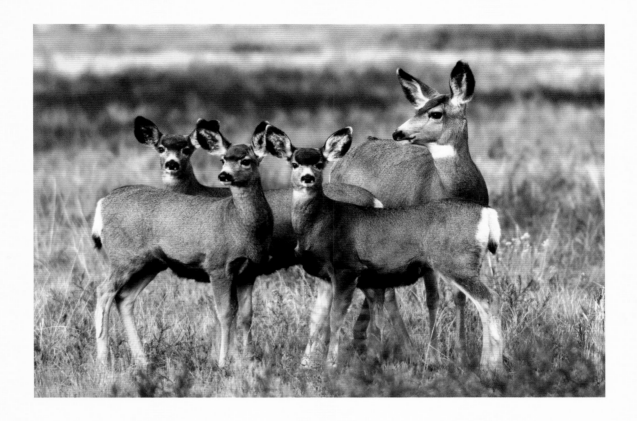

Above: Mule deer are found in abundance in Glacier. In late spring and early summer the females, or does, give birth to their young. It is not unusual for a doe to give birth to twins. Occasionally a doe will give birth to three fawns, as seen in this photo. This is usually a sign of a very healthy deer population. ZACK CLOTHIER

Left: Bitterroot is the state flower of Montana and blooms in varying habitat throughout the state. It can be found in dry forests in Glacier, usually in late May into June. The beautiful, delicate blossoms with their striking pink color stand out on the forest floor. STEPHEN C. HINCH

Far left: The first colors of sunrise light Reynolds Mountain as water cascades down a lichen-covered cliff next to a climber's trail that leads to the summit. STEPHEN C. HINCH

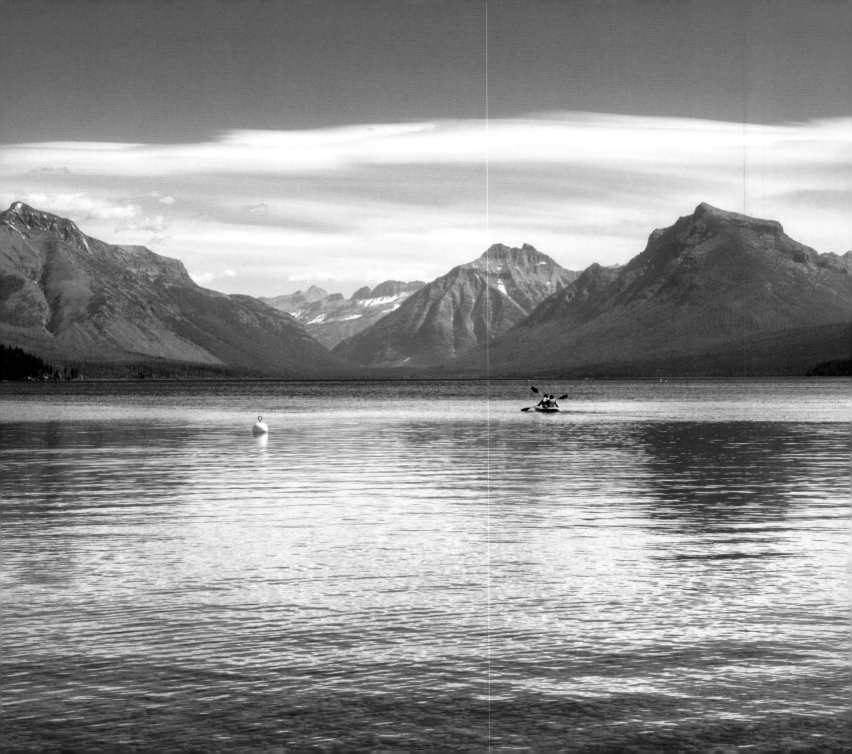

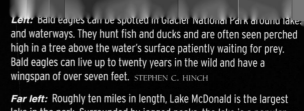

Left: Bald eagles can be spotted in Glacier National Park around lakes and waterways. They hunt fish and ducks and are often seen perched high in a tree above the water's surface patiently waiting for prey. Bald eagles can live up to twenty years in the wild and have a wingspan of over seven feet. STEPHEN C. HINCH

Far left: Roughly ten miles in length, Lake McDonald is the largest lake in the park. Surrounded by jagged peaks, the lake is a popular choice among recreationists, particularly boaters and paddlers. ZACK CLOTHIER

Below: Rafting is a popular summer activity in northwest Montana. The Middle Fork of the Flathead River, running along the southern boundary of the park, provides rafting enthusiasts with plenty of Class II-III whitewater as well as family-friendly scenic floats. ZACK CLOTHIER

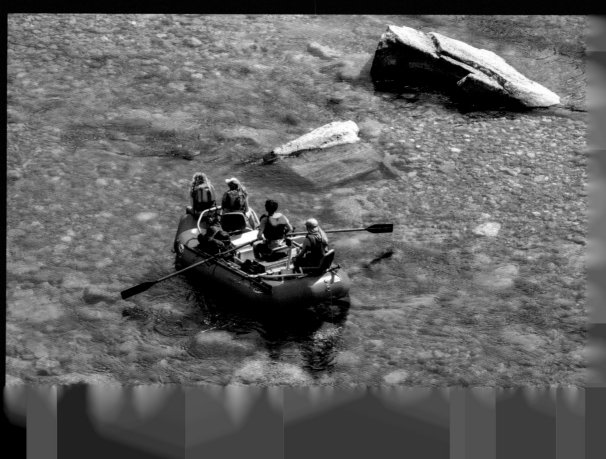

Right: In summer, the Hanging Gardens surrounding Logan Pass are filled with a variety of colorful alpine wildflowers. It's important to stay on all trails and boardwalks in this extremely fragile subalpine area, and to respect all park service closures. ZACK CLOTHIER

Below: Virginia Falls is located on the opposite side of St. Mary Lake from Going-to-the-Sun Road and can be seen from pullouts along the roadway. But the best way to see and experience Virginia Falls is to hike the 1.8 miles to the base of the falls. The main falls drops approximately fifty feet, but then continues in cascades and smaller falls below. STEPHEN C. HINCH

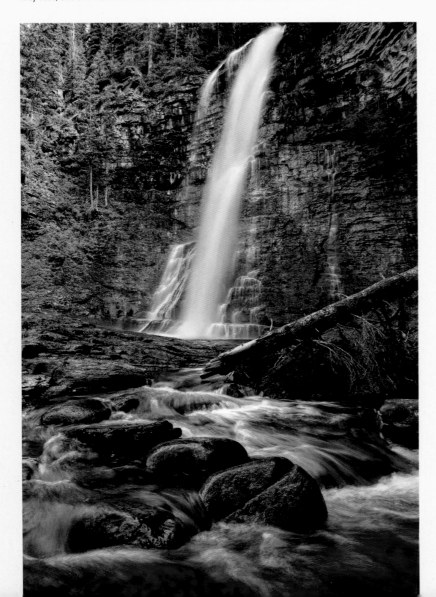

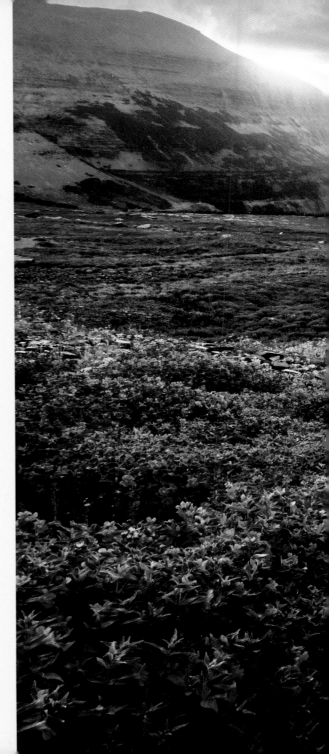

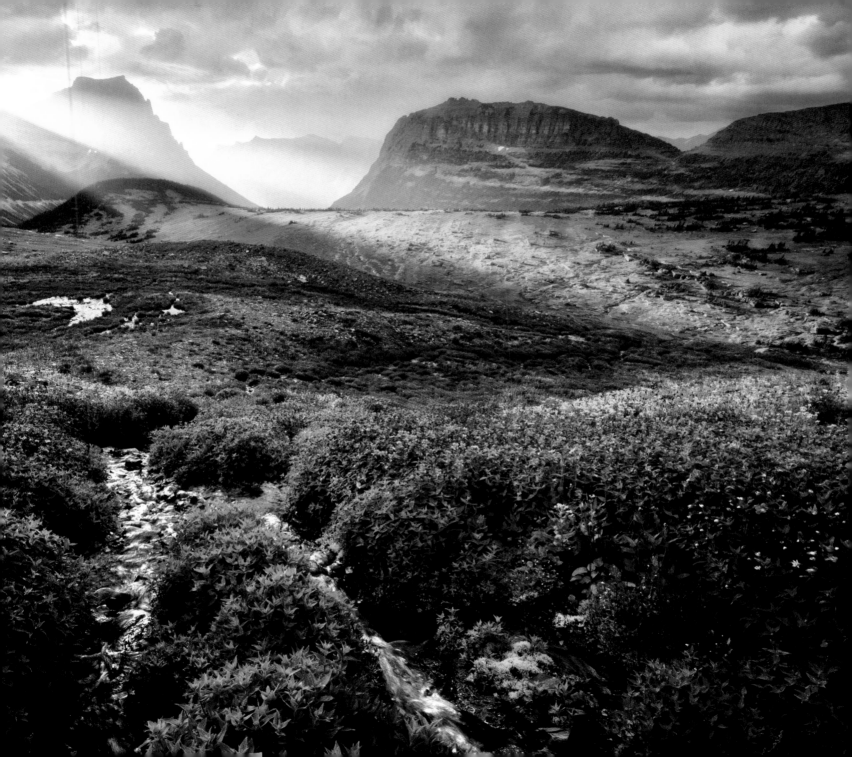

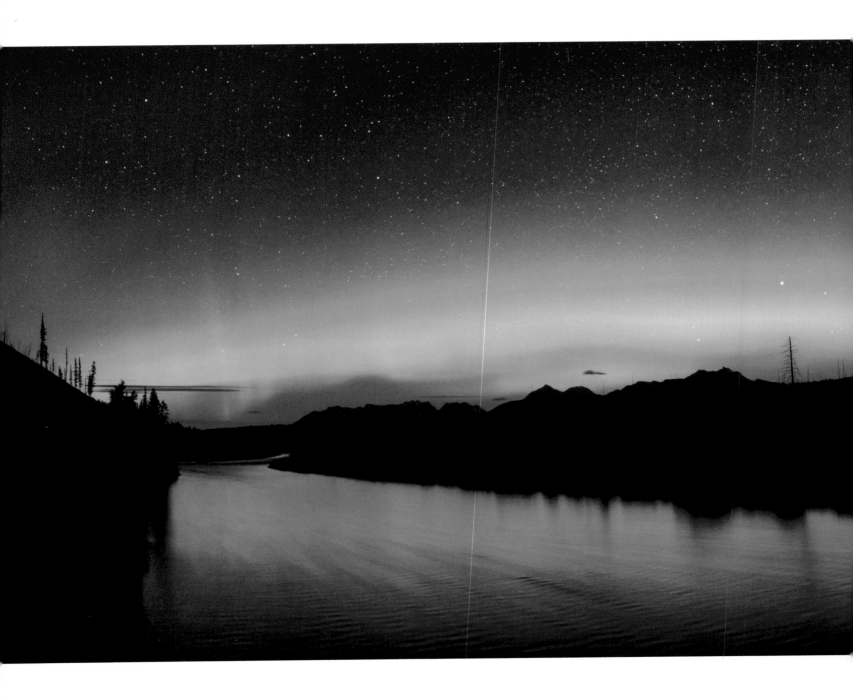

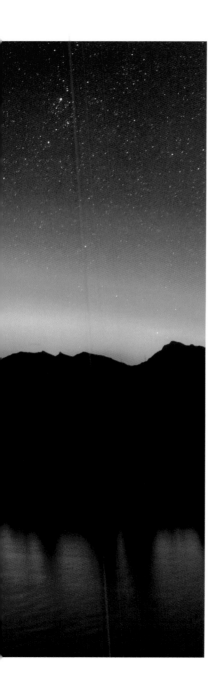

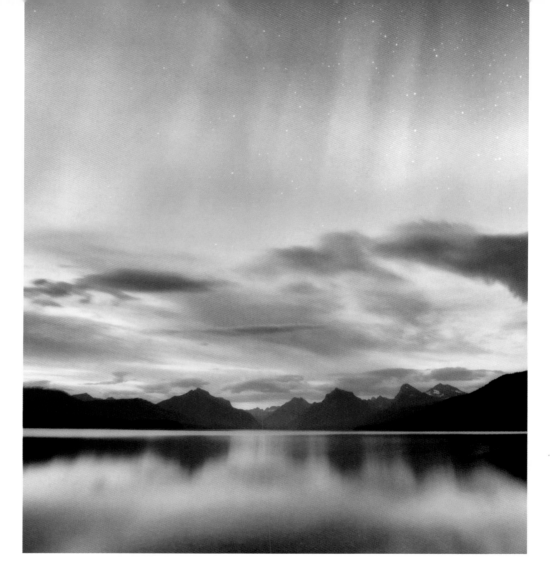

Above: There may be no better spot in the park to view the northern lights than from the foot of Lake McDonald, near Apgar Village, where there is an excellent view of the northern horizon and the rugged peaks that rise above the head of the lake. ZACK CLOTHIER

Left: Glacier National Park is designated an International Dark Sky Park. Far away from light pollution, Glacier and its Canadian counterpart, Waterton Lakes National Park, are home to some of the darkest night skies in the world. While you may have a chance of seeing the aurora borealis, better known as the northern lights, any time of the year, spring and early summer offer the best opportunity to witness this natural wonder of the world. Here the lights dance over the North Fork of the Flathead River, on the western edge of the park. ZACK CLOTHIER

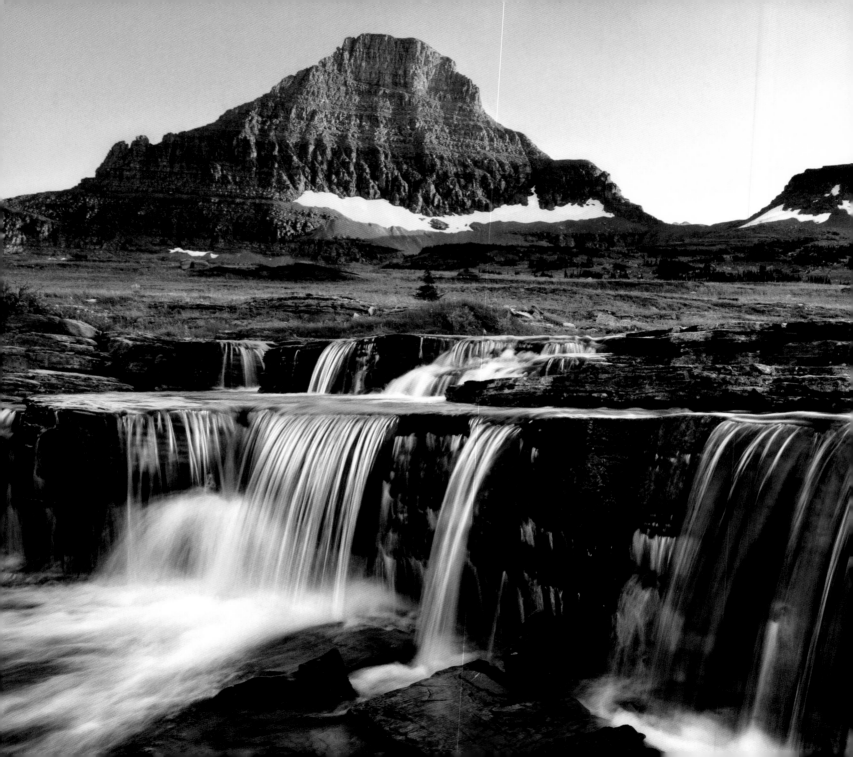

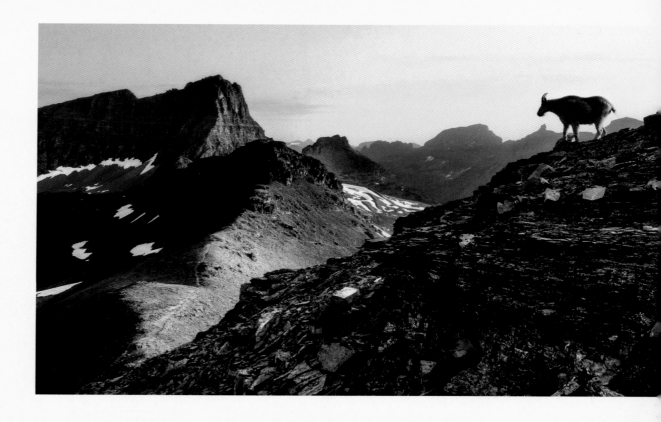

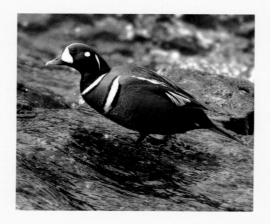

Above: A lone mountain goat takes in the mountainous view at daybreak from a rocky perch near Logan Pass. Mountain goats are powerful, nimble creatures that are well adapted to the alpine environments where they reside. These surefooted animals can often be observed scaling sheer cliffs with what seems like tremendous ease. ZACK CLOTHIER

Left: Harlequin ducks are sea ducks but can be found throughout western Montana in spring and early summer. They prefer fast-moving streams where they feed on aquatic insects. STEPHEN C. HINCH

Far left: The last light of day falls on Reynolds Mountain above Reynolds Creek. This area has since been closed to the public to protect wildlife, seasonal habitat, and revegetation projects, and to avoid damage to the fragile subalpine ecosystem. ZACK CLOTHIER

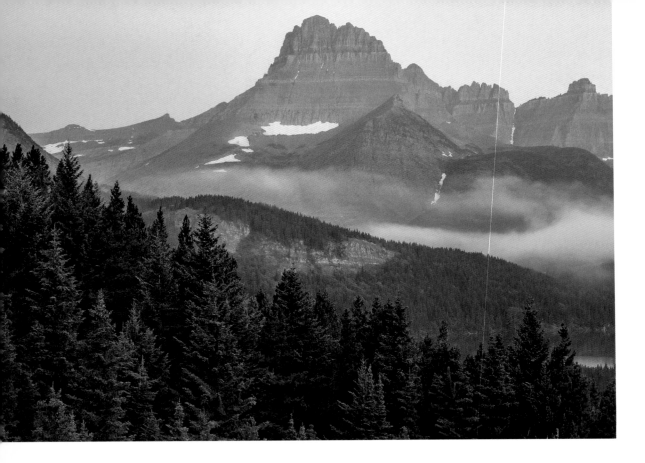

Above: Moody light at sunrise created an interesting color palette on Mount Wilbur as seen from the Cracker Lake Trail. Heavy rain clouds gave way to clear skies, and the color was constantly changing with each opening. STEPHEN C. HINCH

Right: Most people associate wild orchids with the tropics, and they are right. But in the northern Rockies, a small, beautiful orchid can be found in the pine forests in June. Fairy slippers need a certain soil content to grow and can only be found in undisturbed pine forests. STEPHEN C. HINCH

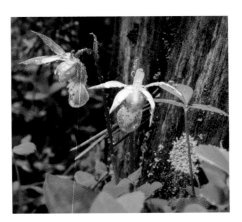

Far right: For those who wish to get away and "rough it," the Two Medicine Lake area, on the southeast side of Glacier, is a wonderful place to visit. A large campground provides the only accommodations and a small general store offers the only amenities. But abundant wildlife, good hiking, and incredible scenery can be found here. STEPHEN C. HINCH

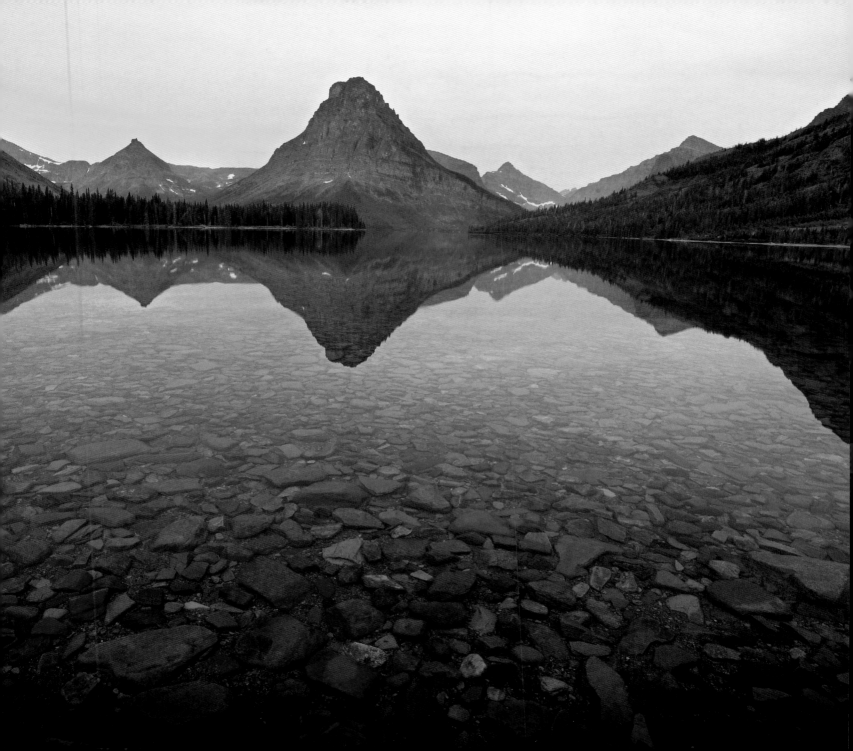

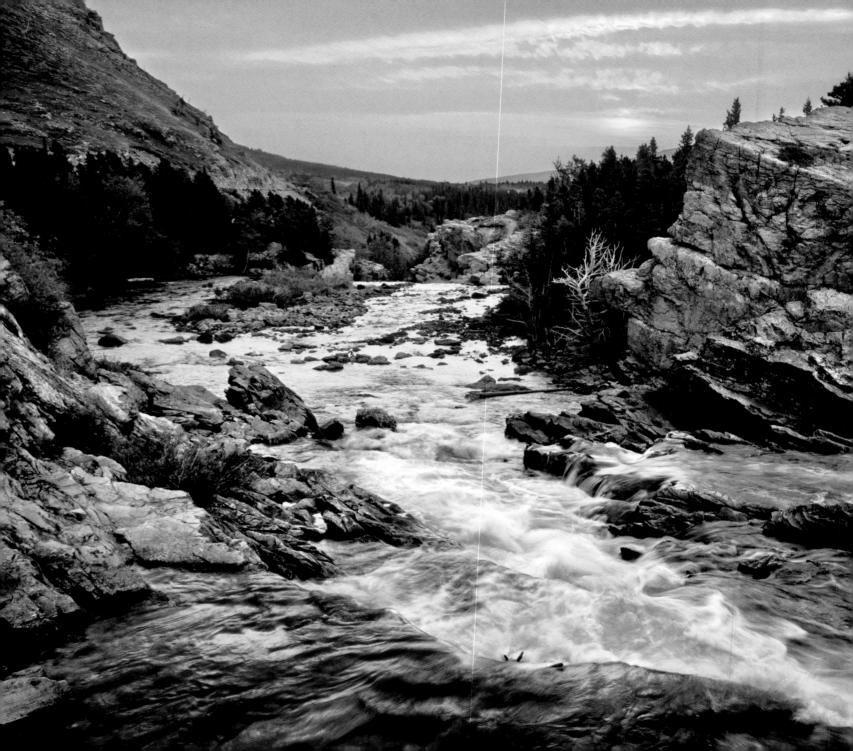

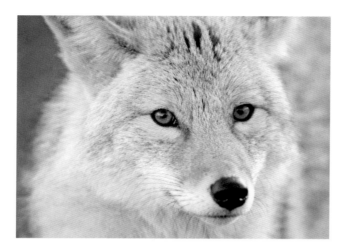

Left: Coyotes are common in the lower elevations of Glacier National Park and surrounding areas. They prefer open meadows where they can hunt for rodents, but can occasionally be seen in other areas, too. STEPHEN C. HINCH

Far left: Swiftcurrent Creek flows from the outlet of Swiftcurrent Lake, in the Many Glacier Valley. For those visiting the Many Glacier area on the park's eastern side, this is a great place to watch the sun rise. ZACK CLOTHIER

Below: Bobcats, like all wild cats, can be difficult to find anywhere—including Glacier. Cats tend to be secretive, and even in places where they may be abundant, they'll often slip off a trail and let hikers go by unnoticed. Obviously I noticed this bobcat, and it noticed a bird in a tree. STEPHEN C. HINCH

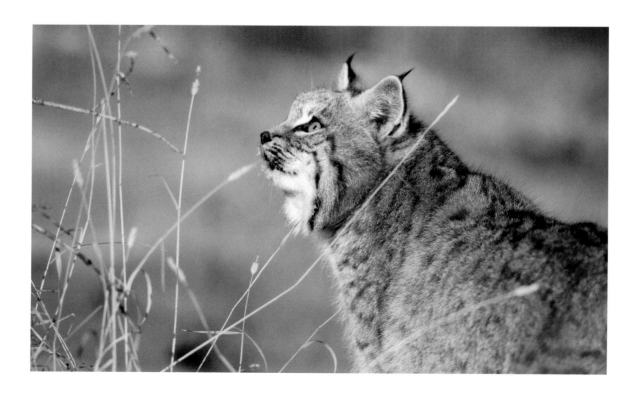

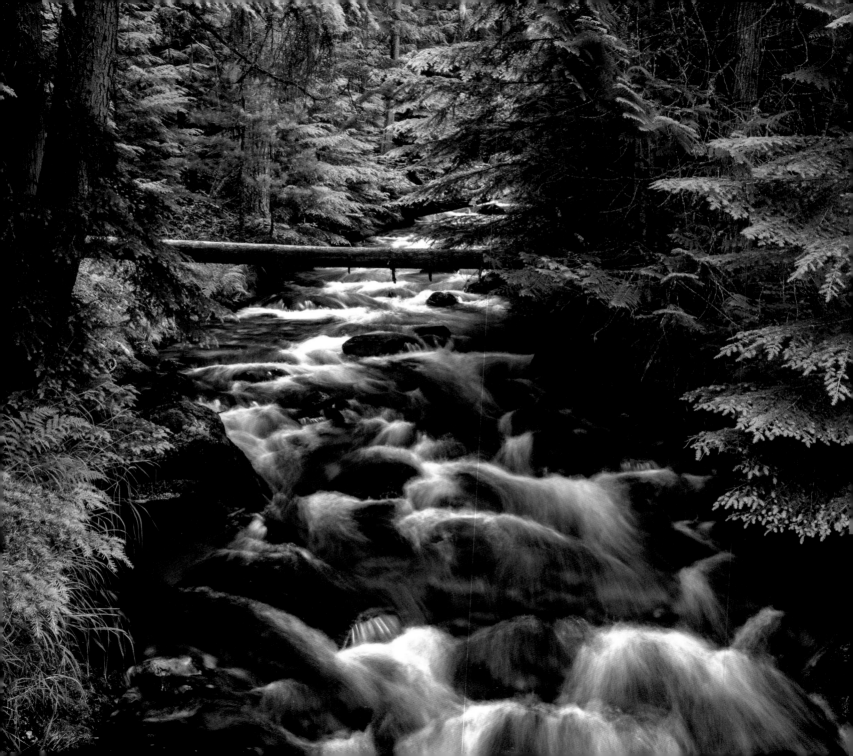

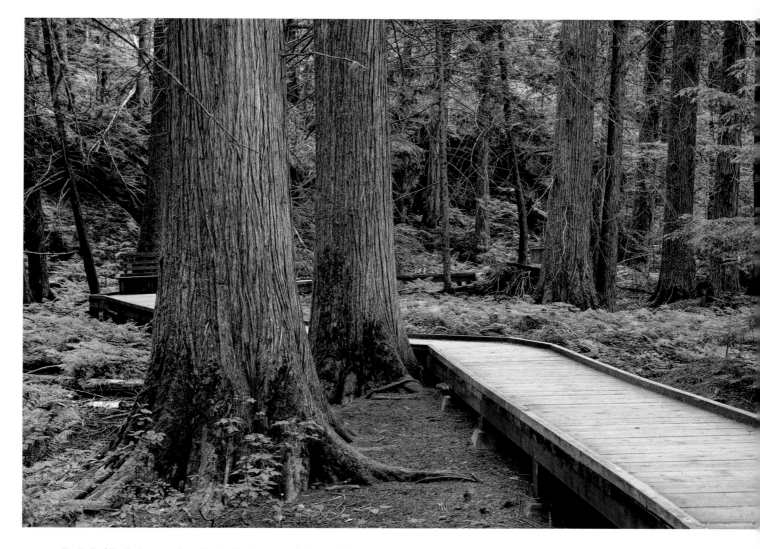

Above: The Trail of the Cedars, near busy Avalanche Campground, is one of the most popular trails in the park and the beginning of the longer hike to Avalanche Lake. The loop trail that makes up Trail of the Cedars is about one mile in length, with boardwalks protecting sensitive marsh areas. The red cedar trees here are over 100 feet tall, and some have diameters from four to seven feet. It is believed some of these trees are more than 500 years old. STEPHEN C. HINCH

Left: Sprague Creek, on the west side of the park, flows through a dark forest of hemlock and cedar before emptying into Lake McDonald. Glacier National Park boasts over 1,550 miles of crystal clear streams, mostly fed by alpine glaciers and winter snowpack. ZACK CLOTHIER

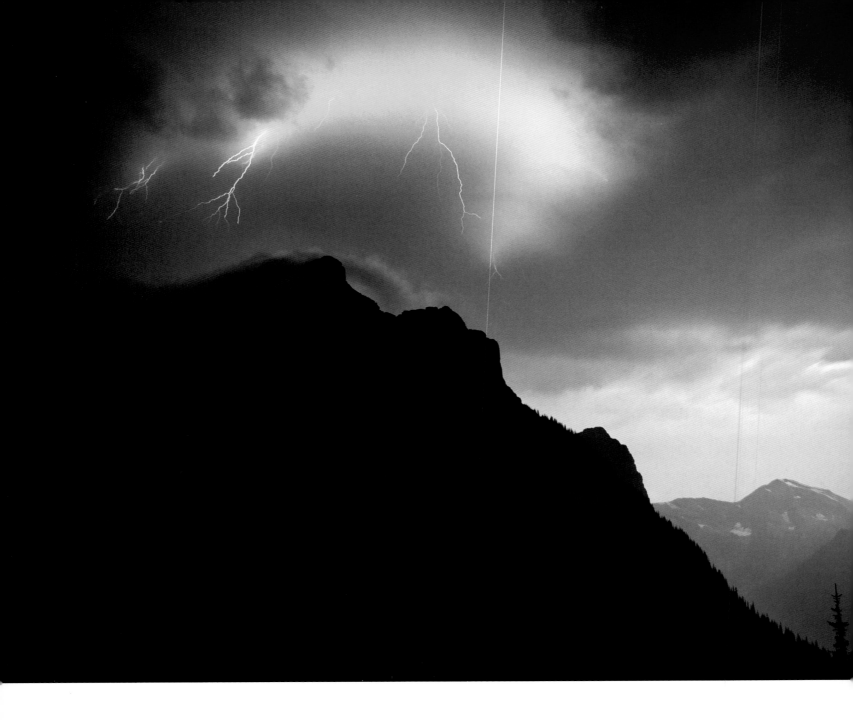

Left: Being situated along the Continental Divide, Glacier's geography lays the groundwork for dynamic clashes of opposing climates. When the warm, moist air mass of the Pacific and cold, drier arctic air come together at the divide, dramatic weather often ensues. ZACK CLOTHIER

Below: Lunch Creek is a long, continual cascade that pours down the valley before crossing under the Going-to-the-Sun Road. It eventually joins Reynolds Creek and then the St. Mary River. Wildflowers are common here, and a wide assortment can often be seen, including yellow columbine, which loves moist areas. Pollock Mountain rises above the creek in the background. STEPHEN C. HINCH

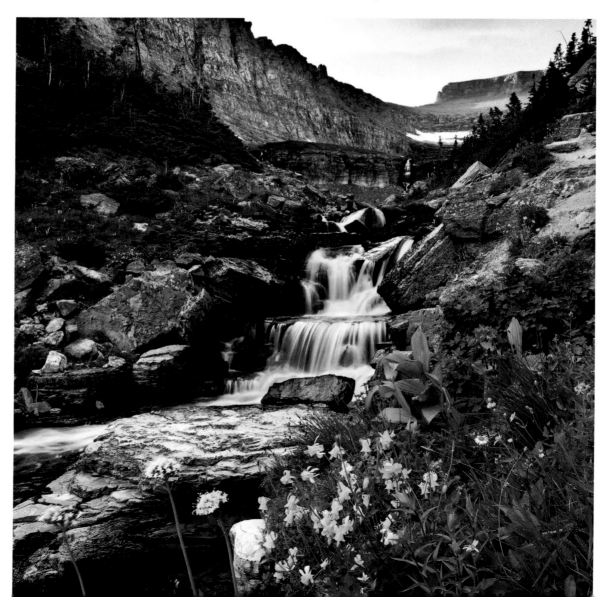

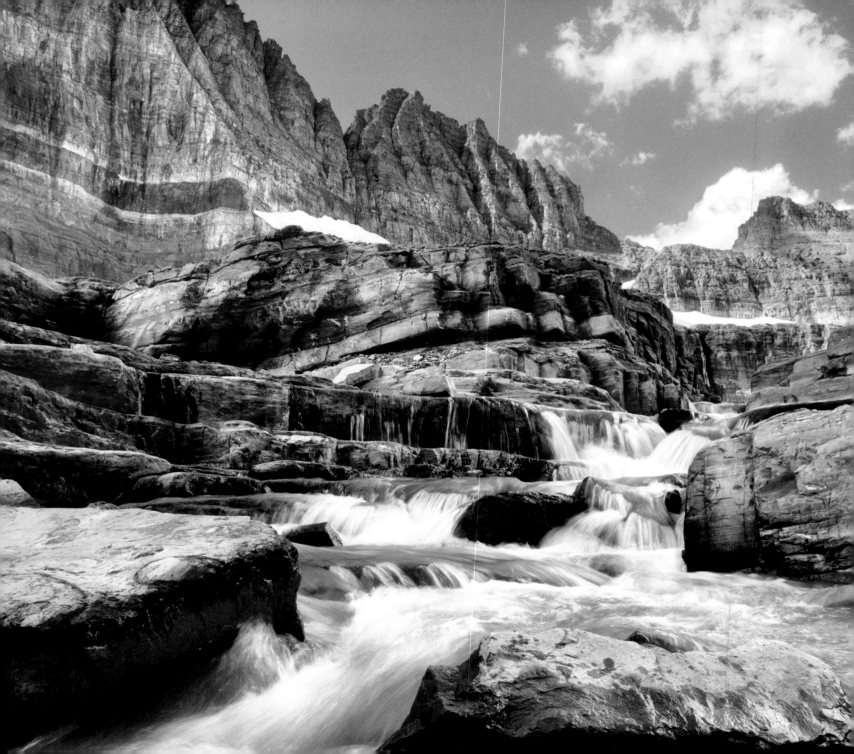

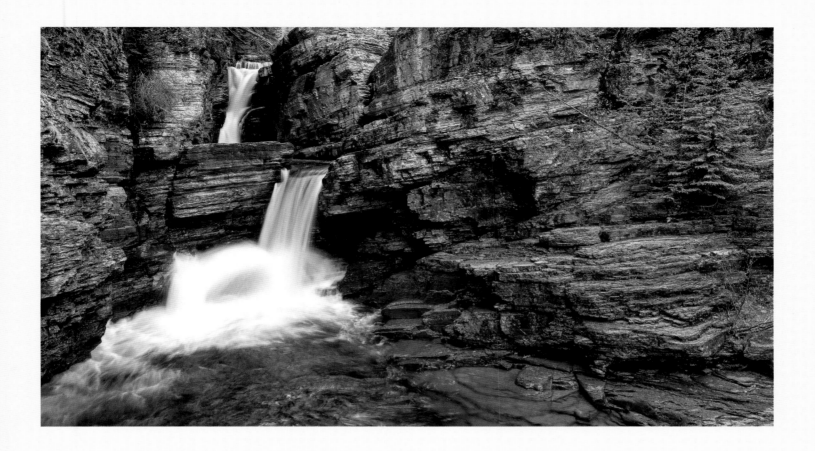

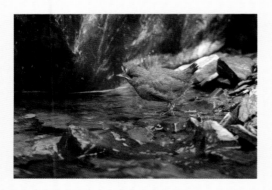

Above: St. Mary Falls is a beautiful drop of thirty-five feet. Two tiers of the falls can be seen, while the third one crosses under the bridge over the St. Mary River. A round-trip hike of 1.7 miles is required to view the falls, and trailhead parking can fill quickly. Using the park shuttle is a great way to avoid the hassle of finding parking and focus on enjoying the beauty of the park. STEPHEN C. HINCH

Left: The American dipper is a small gray bird also called a water ouzel. Dippers spend most of their time around water where they dive to hunt aquatic insects. Oil in their feathers insulates and keeps them dry, and they have an extra eyelid called a nictitating membrane that allows them to see underwater. STEPHEN C. HINCH

Facing page: Salamander Falls as viewed from the outlet of Upper Grinnell Lake, a glacially fed alpine lake below the receding Grinnell Glacier. It is a relatively new lake that formed in the 1930s as the glacier retreated. The trail leading to Grinnell Glacier passes through prime grizzly bear habitat. When hiking anywhere in the park, it is highly recommended that you carry bear spray. ZACK CLOTHIER

Right: Hoary marmots are larger than their cousin, the yellow-bellied marmot, and are commonly seen in Glacier's high country. This one sat on a large boulder near Logan Pass at sunrise, which made the mountains in the background glow in various shades of orange. STEPHEN C. HINCH

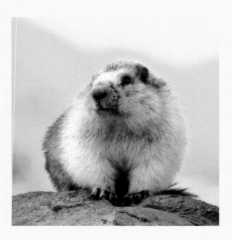

Far right: The summer sun rises over one of the most iconic mountains in the park. Going-to-the-Sun Mountain is a prominent peak rising dramatically above the St. Mary Valley. The mountain is also visible looking east from Logan Pass. ZACK CLOTHIER

Below: Moose are frequently spotted in Glacier National Park. A majority of sightings occur on the eastern side of the park, with the Many Glacier Valley being the most notable place to spot this largest antlered member of the deer family. In summer, a moose's diet consists mainly of underwater vegetation found at the bottom of shallow lakes and small ponds. Moose are powerful swimmers and are capable of diving underwater for short periods of time, which allows them to take advantage of this nutrient-rich food source. Moose are large, highly unpredictable animals. Respect their space and always observe them from a safe distance. ZACK CLOTHIER

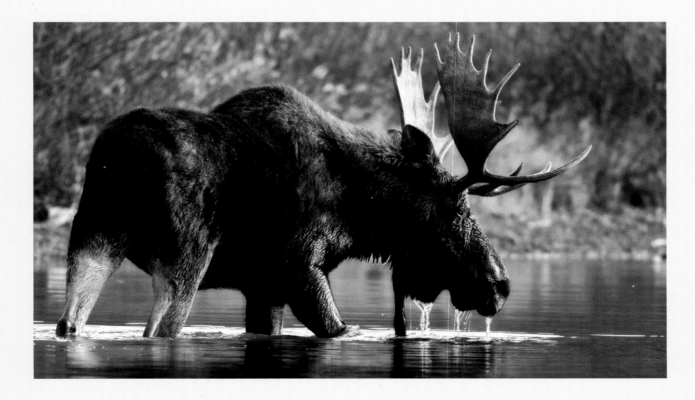

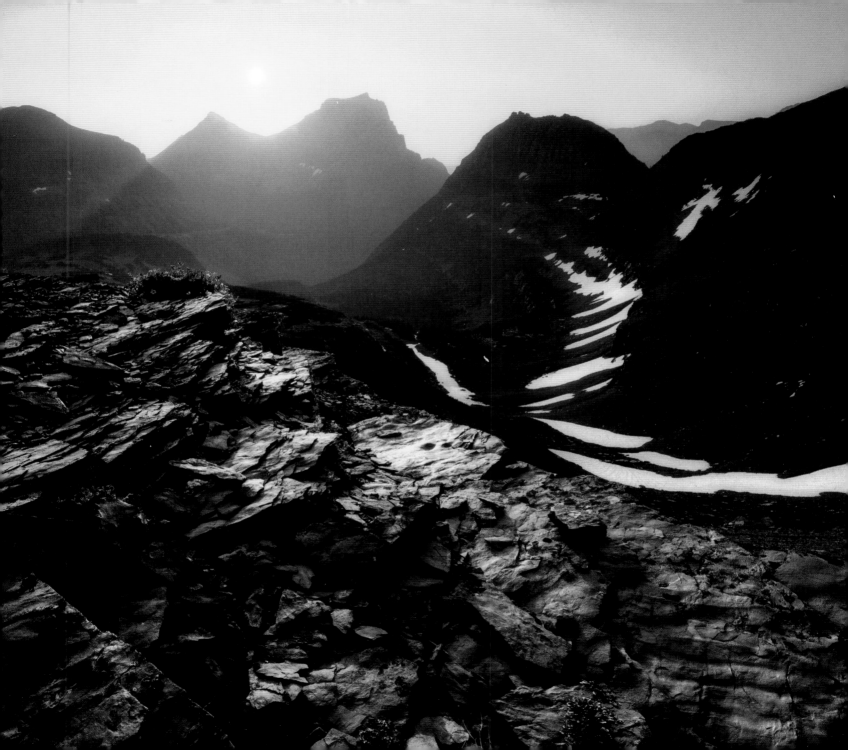

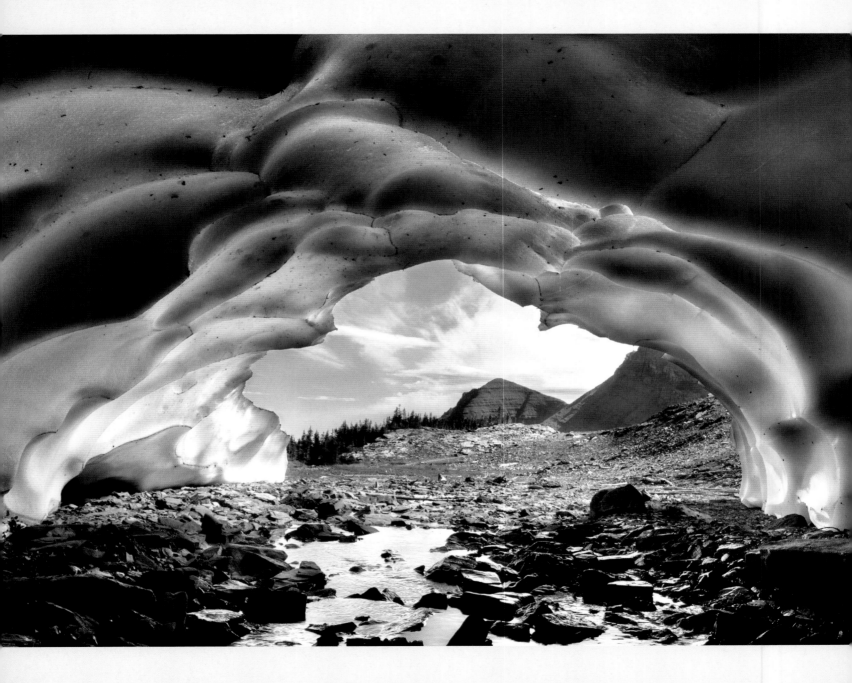

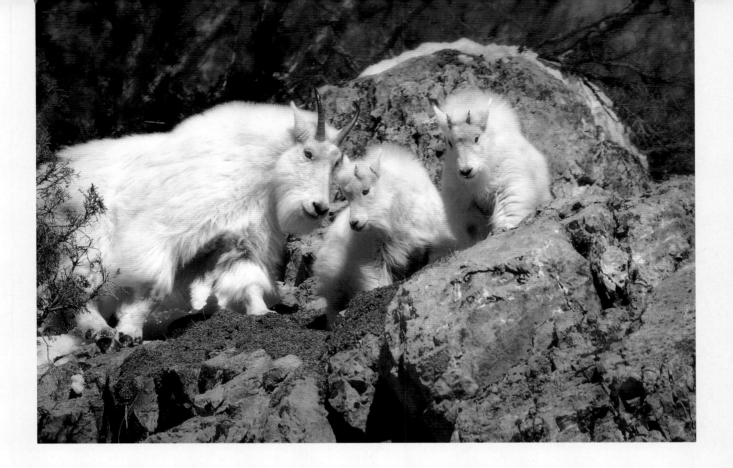

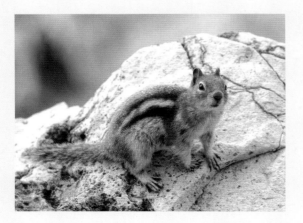

Above: Mountain goats are one of Glacier's most commonly sought after mammals for wildlife viewing and are regularly seen in the high country. They prefer places near steep cliffs that serve as defense. Their hooves are uniquely adapted for cliff climbing with soft pads, which help them grip the rocky slopes. The young learn quickly how to negotiate the steep habitat from their mothers. STEPHEN C. HINCH

Left: Golden-mantled ground squirrels are often confused for the much smaller chipmunk. These ground squirrels use different habitat than chipmunks do, preferring rocky, open areas. Like most rodents, they hibernate during Glacier's long winters but are frequently seen throughout the short summer season. STEPHEN C. HINCH

Far left: A unique view of the mountains from a small snow cave in Glacier's backcountry. Snow caves, or snow tunnels, are carved out by meltwater streams. Once an opening has been created by the water, an inrush of warmer air beneath the snow causes an expansion of the cave. ZACK CLOTHIER

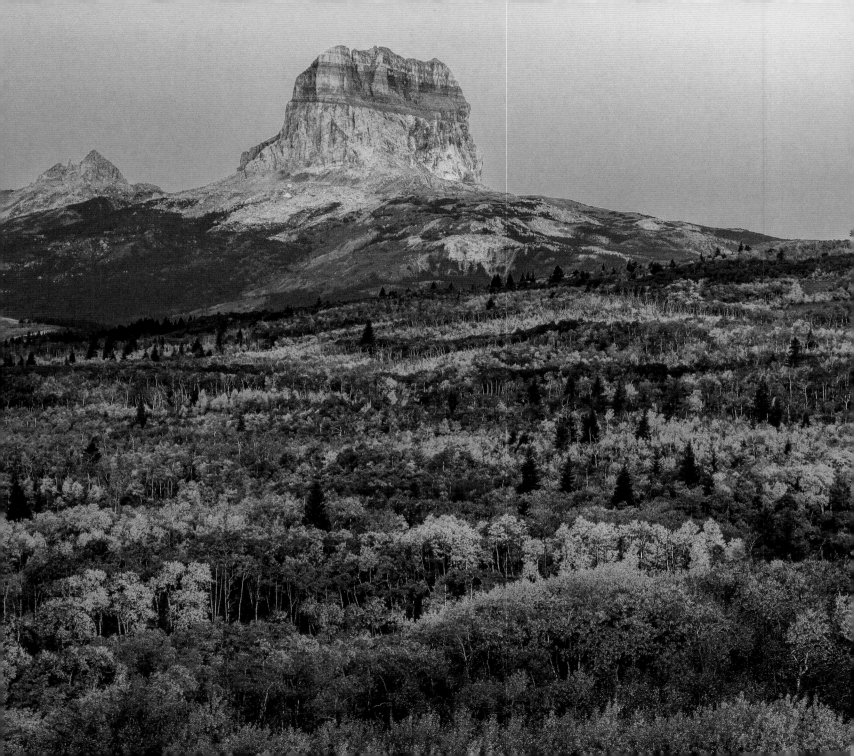

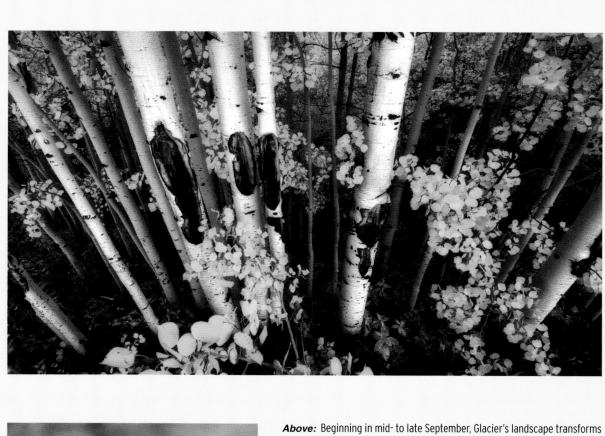

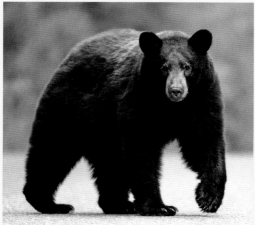

Above: Beginning in mid- to late September, Glacier's landscape transforms with autumn's hues. A majority of the color comes from deciduous stands, which are found on the drier eastern side of the park. This golden stand of aspen trees was photographed near St. Mary. If you look closely at the tree trunks, you may see the telltale markings left behind by black bears. During the spring, black bears will often climb aspens to reach catkins, a favored early season food source. ZACK CLOTHIER

Left: Black bears are found throughout the forests of Glacier National Park. It is not uncommon to come across one of these animals while hiking in the park. Occasionally they are spotted from the roadways, such as this one near Polebridge, especially in the fall when the berries are ripening. ZACK CLOTHIER

Far left: Chief Mountain towers above the surrounding landscape. The mountain is sacred to many Native Americans, and its current name comes from the Blackfeet name that means "Great Chief." STEPHEN C. HINCH

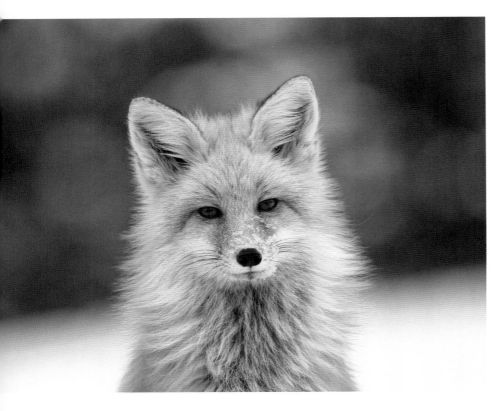

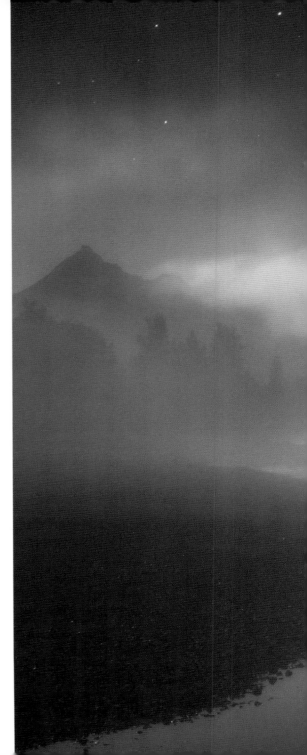

Above: Red foxes are common throughout North America, and Glacier National Park is no exception. Due to the forest cover in lower elevations, foxes can be difficult to find, but when snow covers the landscape, they can be easier to see. Foxes hunt rodents, small mammals, and birds, but will eat anything they can scavenge. STEPHEN C. HINCH

Right: The St. Mary River gleams on a chilly September night. Here, the heavy fog settling in beneath the dramatic peaks of Glacier caught the light from a waxing gibbous moon, evoking a sense of mystery and mood. ZACK CLOTHIER

Next pages: A hiker looks out over Hidden Lake with Bearhat Mountain in the background. Glacier National Park encompasses just over one million acres of pristine forests, glacier-carved peaks and valleys, alpine meadows, and sparkling lakes. The park is a haven for adventurous visitors seeking wilderness and solitude. ZACK CLOTHIER

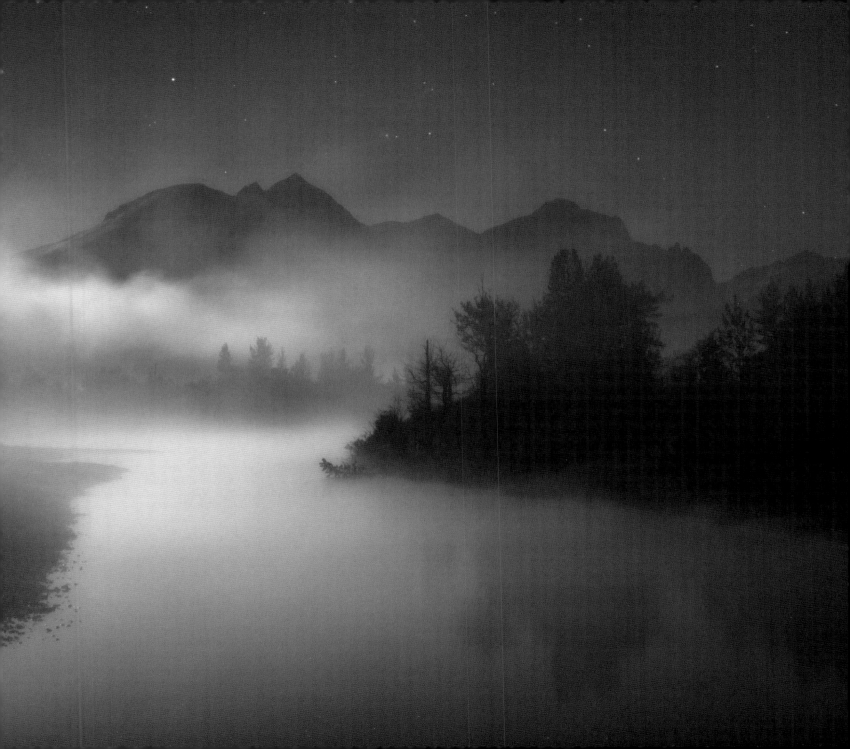

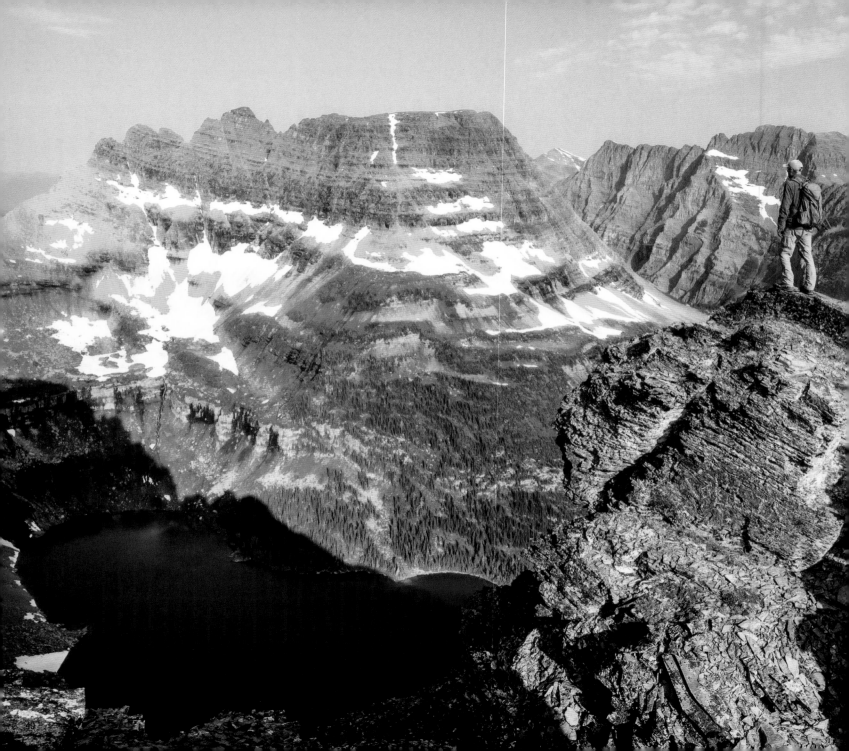

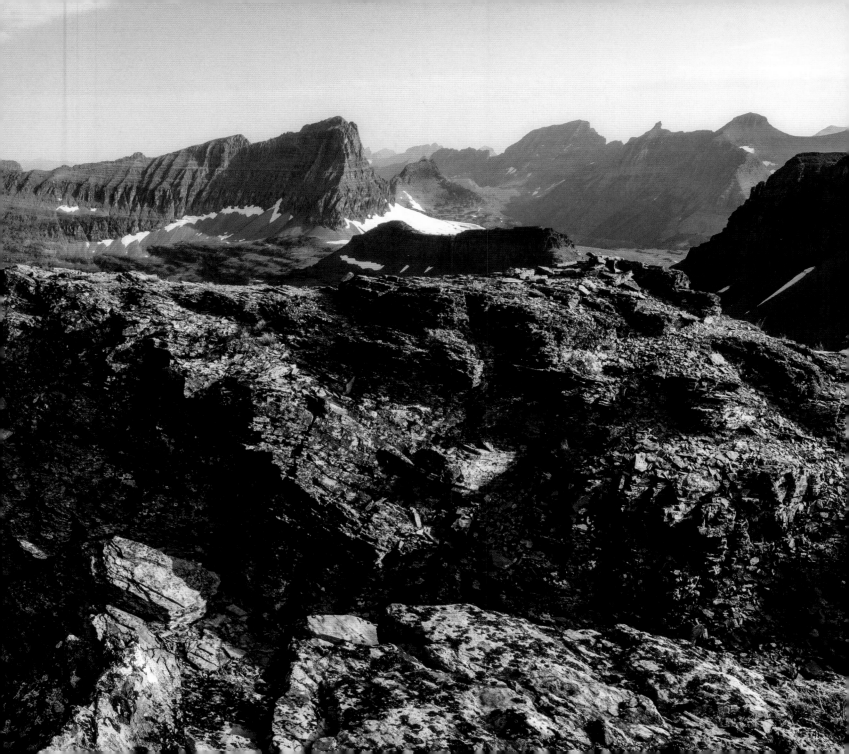

Right: Red Bus tours depart daily from many locations throughout the park, including the historic Lake McDonald Lodge on the park's west side. Soaring peaks, glaciers, waterfalls, and wildlife await discovery as you travel through the park in one of these historic buses. ZACK CLOTHIER

Far right: Lake McDonald Lodge, built in 1913, sits on the southeast shore of Lake McDonald. The Snyder Hotel was originally built at this location in 1895, but was sold and replaced by the Lewis Glacier Hotel. The Great Northern Railway acquired the property in 1930, and in 1957 the name was changed to Lake McDonald Lodge. STEPHEN C. HINCH

Below: The main lobby of the Lake McDonald Lodge features a large stone fireplace in a rustic setting. Three stories tall, the room reveals the heavy timber framing of the lodge and is decorated with taxidermy mounts of several native species. ZACK CLOTHIER

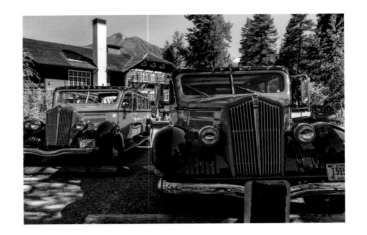

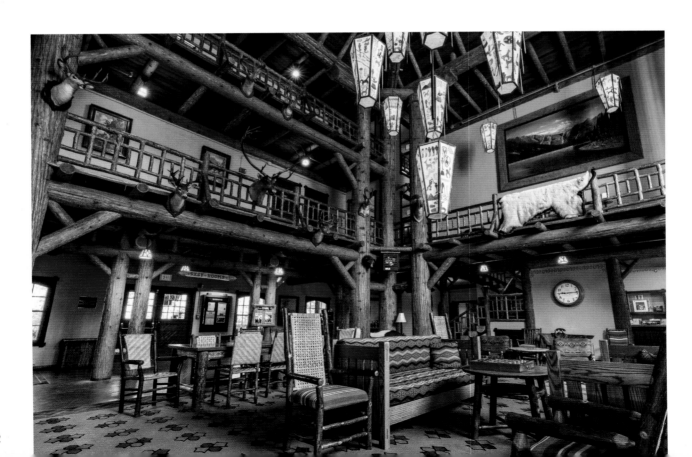

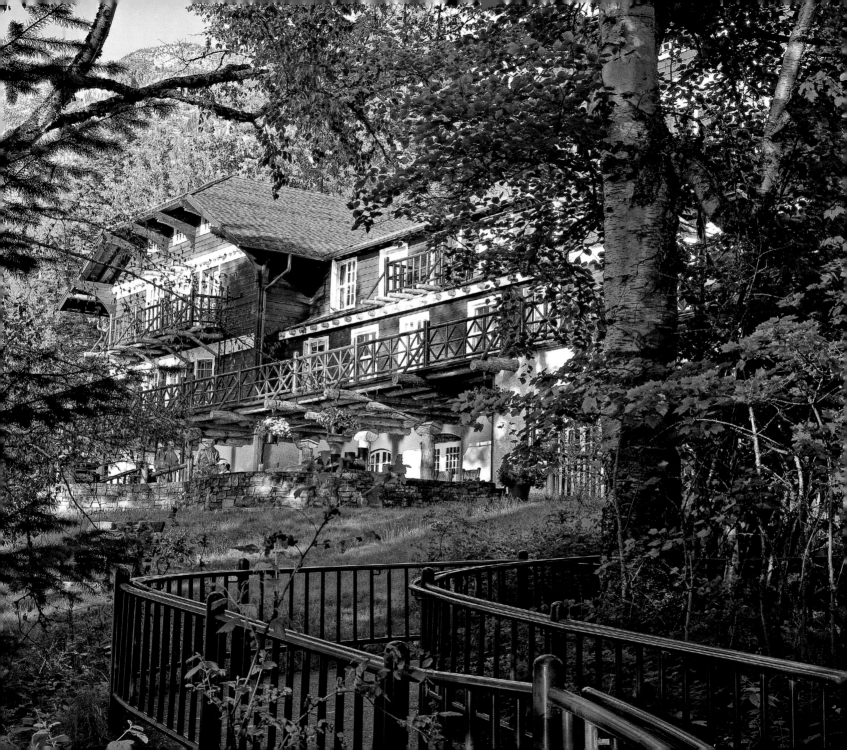

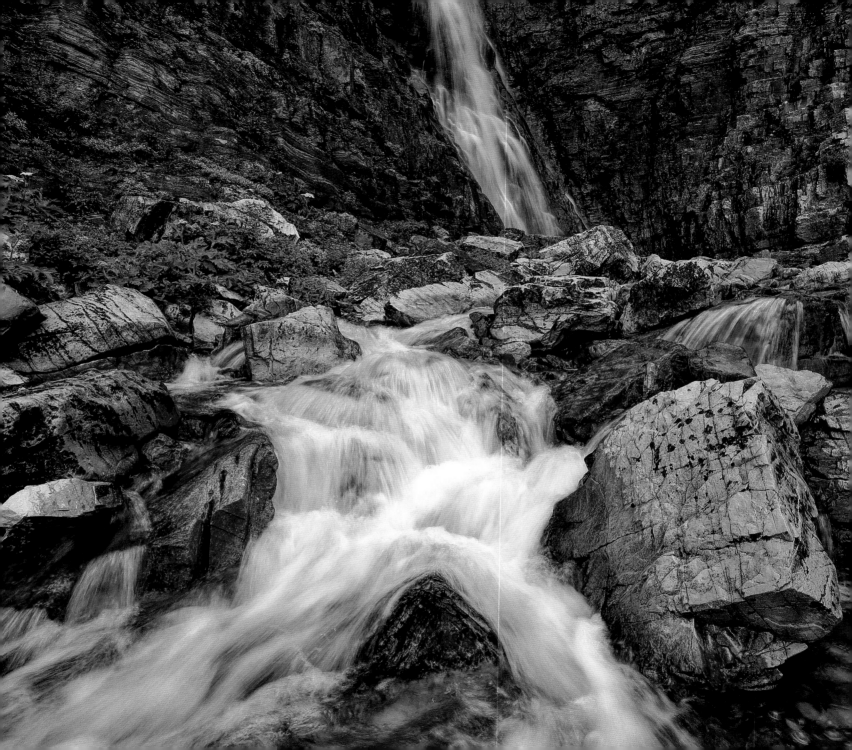

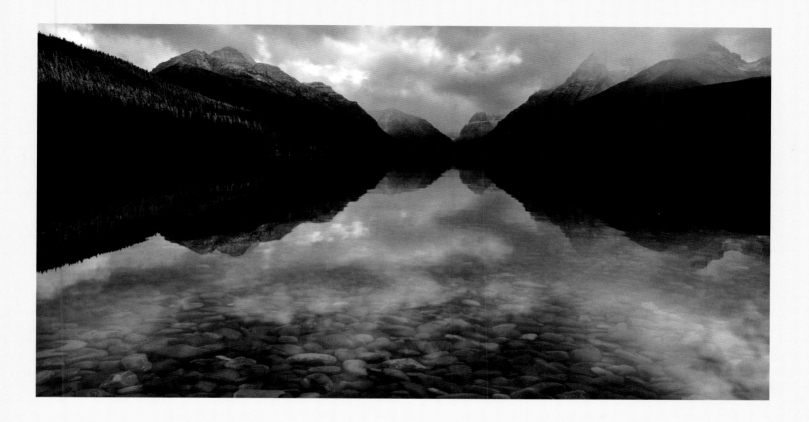

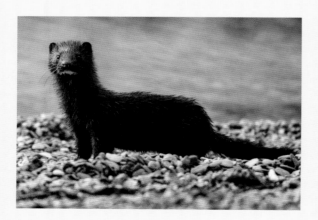

Above: Bowman Lake is a beautiful mountain lake located in the remote northwest corner of the park. Because of this, it receives fewer visitors than some of the more well-known areas in Glacier. The lake boasts a frontcountry campground, making it a lovely spot to spend a night or two. Those looking for solitude will enjoy the many recreational opportunities, such as kayaking, canoeing, fishing, and hiking, that can be found just a short distance from the campground. If you need to stock up on supplies, the quaint community of Polebridge is just a short, albeit rough-dirt-road, drive away. ZACK CLOTHIER

Left: The American mink is the only semi-aquatic species of mustelid found in Glacier National Park. Its preferred habitat includes areas with a permanent water source. Mink can often be found foraging near lakes, streams, and other wetland habitats. Due to their largely nocturnal nature, however, they are seldom seen. ZACK CLOTHIER

Facing page: Apikuni Falls is the reward for a short but steep hike in the Many Glacier area. A round-trip hike of approximately 1.8 miles leads to this beautiful scene where Apikuni Creek plunges over a steep cliff before flowing down a series of pretty cascades. STEPHEN C. HINCH

Right: A colorful cottonwood leaf offers a striking contrast to the turquoise, purple, and red rocks that lie barely submerged beneath the water's surface. Fall is a perfect time to explore the Middle Fork of the Flathead River, which runs along Glacier National Park's southern boundary, paralleling U.S. Highway 2. ZACK CLOTHIER

Far right: The Two Medicine Valley offers remarkable scenery. Sinopah Mountain, pictured here above Pray Lake, dominates the skyline to the west and is sure to grab the attention of those who visit this special area. ZACK CLOTHIER

Below: Sinopah Mountain also provides a stunning background for canoeing or kayaking on Two Medicine Lake, as well as for the boat tours that are offered during the summer months. STEPHEN C. HINCH

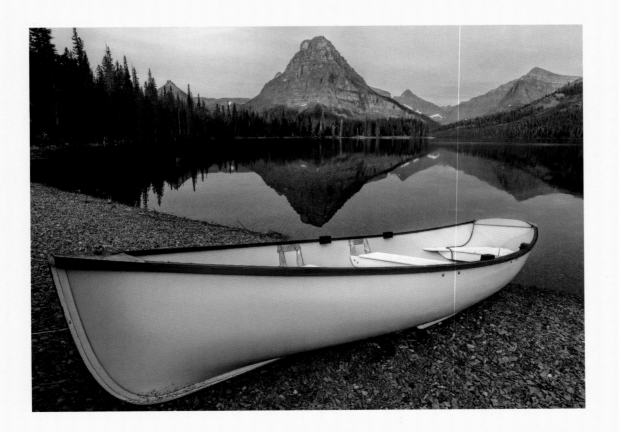

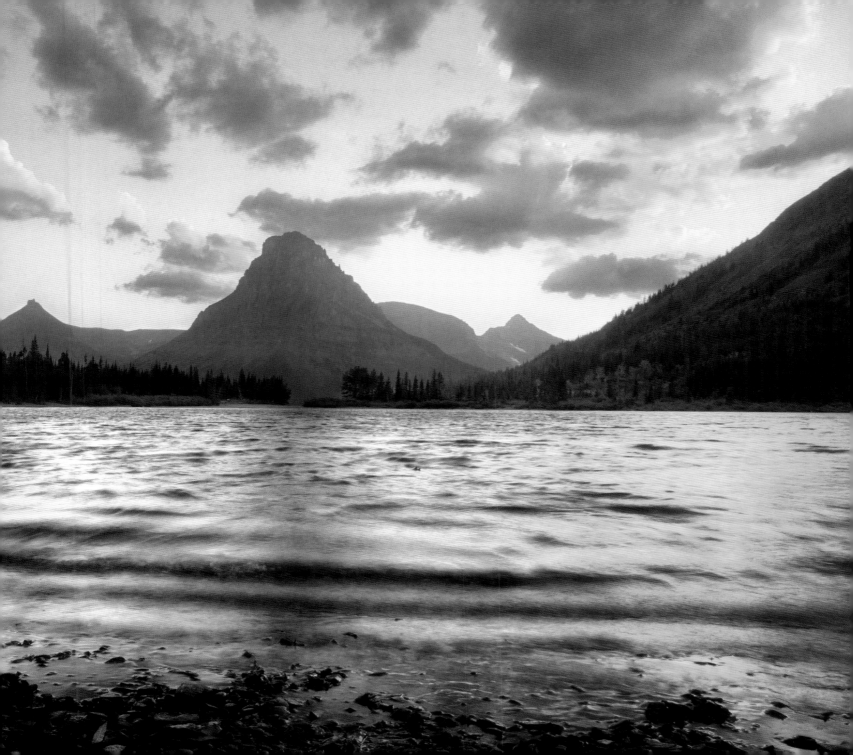

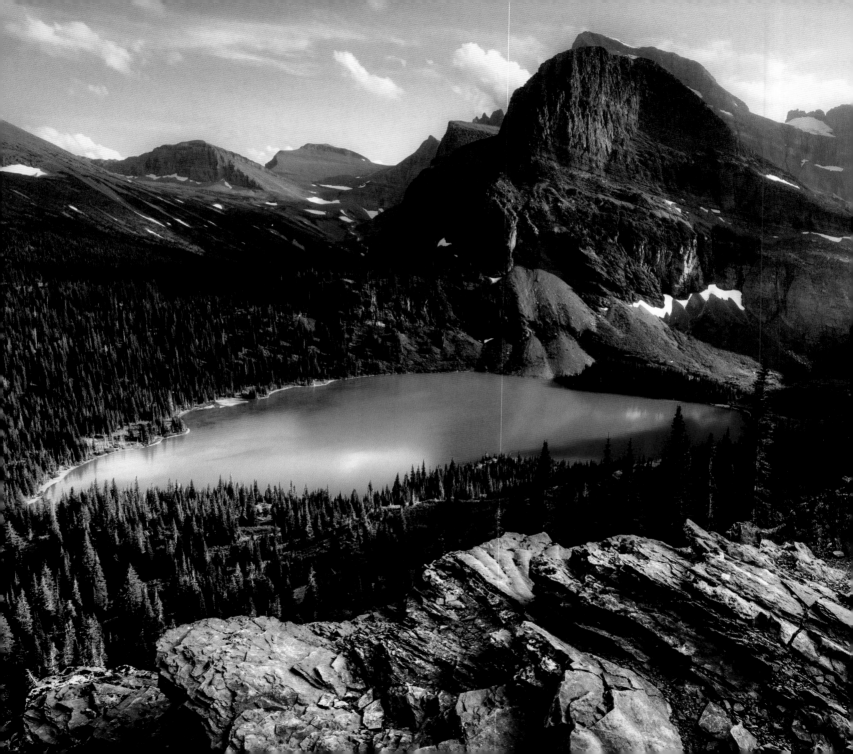

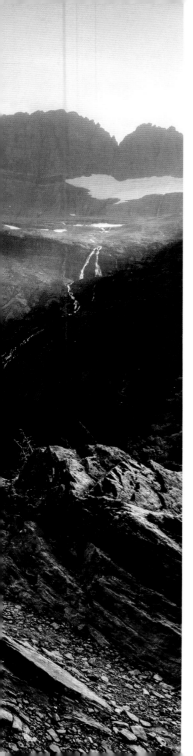

Left: Mountains, glaciers, wildlife, waterfalls, wildflowers—the Grinnell Glacier Trail has something for everyone. One of the most scenic routes in Glacier, the hike overflows with classic postcard views. The trail starts by skirting the shores of Swiftcurrent Lake and Lake Josephine. Mount Gould towers above the brilliant turquoise-colored water of Grinnell Lake as you ascend nearly 1,600 feet above the valley floor. In summer, a variety of alpine wildflowers adorn the subalpine terrain. Bring a pair of binoculars to scan the mountain meadows and cliffs for moose, grizzly bears, bighorn sheep, and mountain goats, which are frequently observed in this area. ZACK CLOTHIER

Below: At barely over one mile in length, the trail to Avalanche Gorge is just one of the incredible sites along Going-to-the-Sun Road. The well-marked Trail of the Cedars winds through a forest of ancient red cedars and western hemlocks. Continuing up the trail, you come to a small footbridge spanning Avalanche Creek. From the bridge there is an excellent view of Avalanche Gorge, where the glacial water of Avalanche Creek carves its way through a narrow chasm of red rock. ZACK CLOTHIER

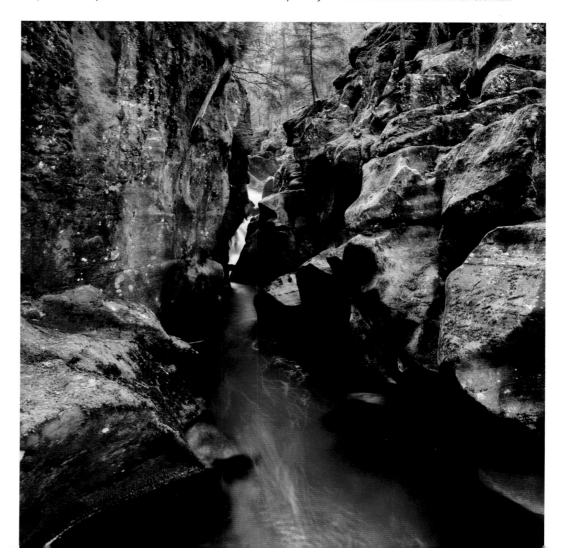

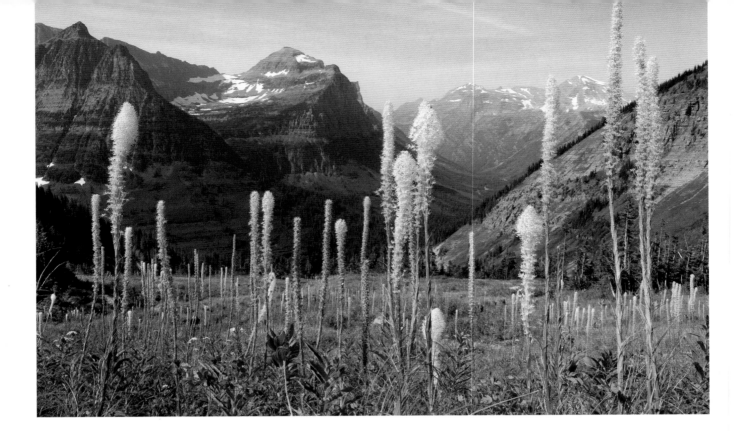

Above: When beargrass blooms in profusion in the northern Rockies, it's a sight to behold. Not actually a grass, this beautiful flower often provides an outstanding foreground in many photographs showcasing the stunning mountains of Glacier National Park. It can start blooming as early as June at lower elevations, and can be seen in high mountain meadows during the middle of the summer season. STEPHEN C. HINCH

Right: Glacier National Park is home to both grizzly and black bears. This sow, or female, black bear had two cubs, one black and one cinnamon. Black bears can come in a variety of colors, including those seen here as well as blonde and chocolate—not just black as their name would imply. STEPHEN C. HINCH

Far right: You never know when a little magic might occur. One moment Logan Pass was socked in with low clouds and rain, but within the next few minutes, the clouds parted and a beautiful rainbow appeared. Weather can change quickly in the northern Rockies, and it's important to be prepared for those changes, especially if planning to hike the trails. STEPHEN C. HINCH

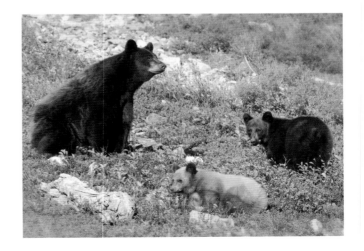

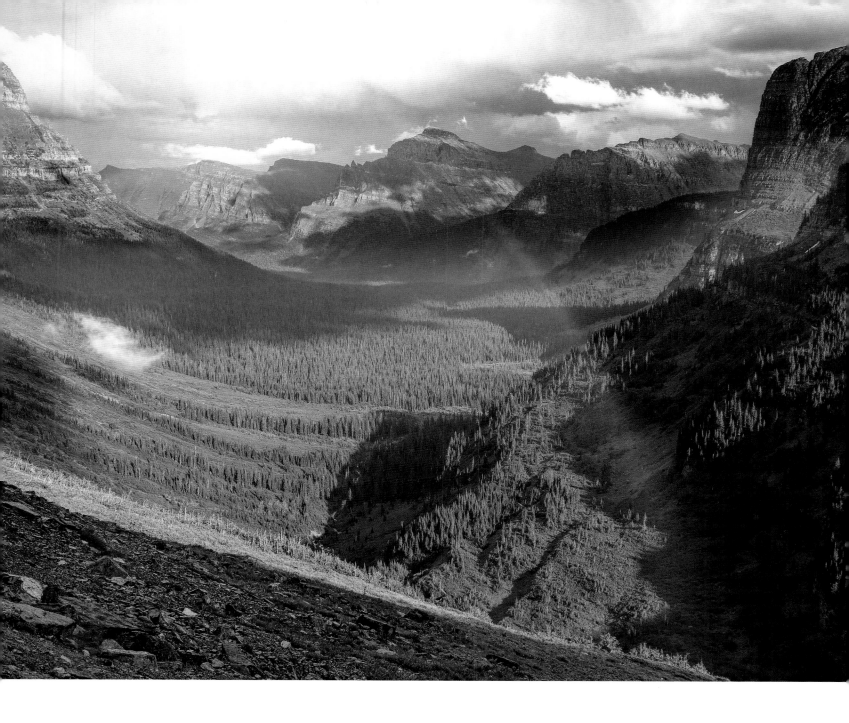

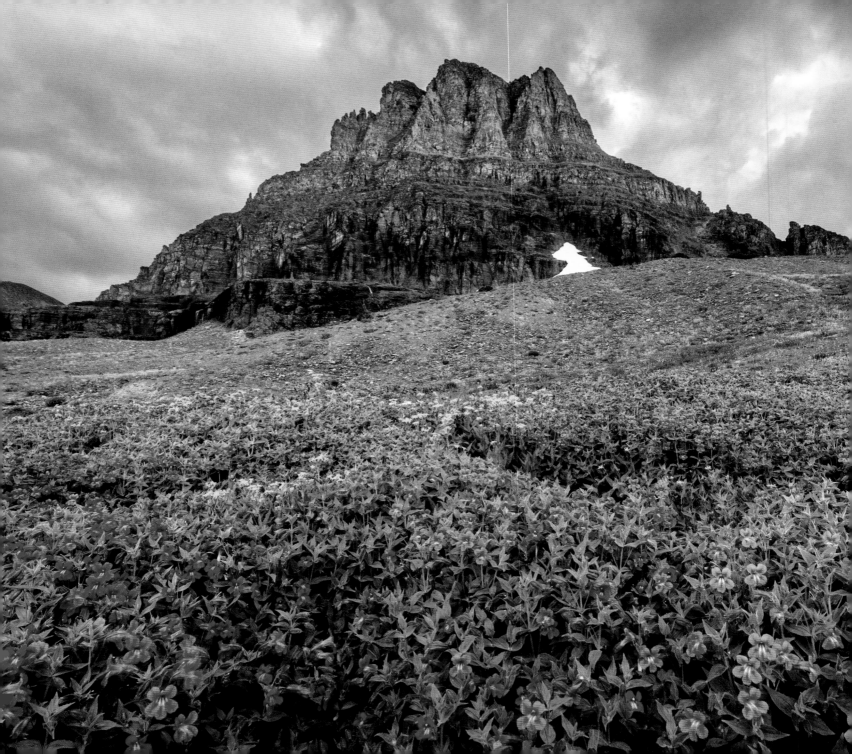

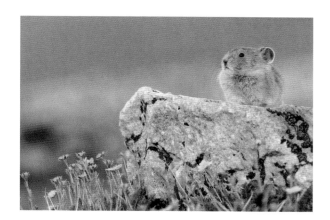

Left: Pikas are inhabitants of the high mountain regions, and are more often heard before they're seen as they bleat loudly to warn of intruders. Around six to nine inches in length, pikas do not hibernate but instead create piles of dried grass in their dens that will feed them through the winter months. STEPHEN C. HINCH

Far left: A carpet of monkey flower and arnica spreads beneath Clements Mountain. This is just one of the many views that can be enjoyed while hiking the Hidden Lake Nature Trail, which starts behind the visitor center at Logan Pass. ZACK CLOTHIER

Below: White-tailed deer are common around the low elevations of Glacier National Park and surrounding areas. Often seen around Apgar, they give birth in late June, and fawns may be seen with their mothers shortly after. As with all deer species, only the males have antlers. STEPHEN C. HINCH

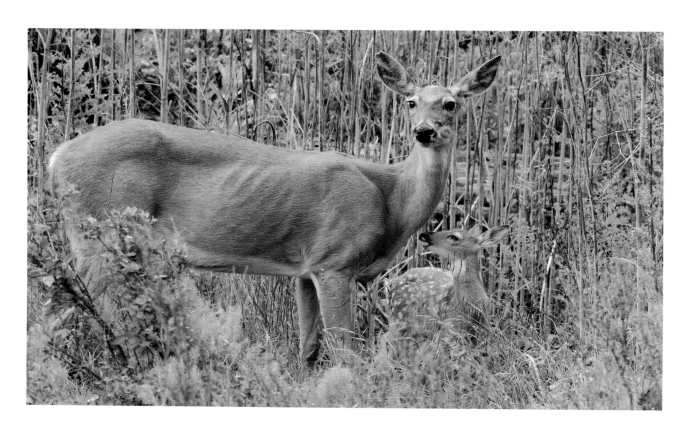

Right: Pine grosbeaks are a common songbird of the pine forests of Glacier, though you are more likely to hear one rather than see one. A member of the finch family, pine grosbeaks are about the size of a robin. Males have red and gray plumage while females have a slightly more dull-yellow with gray coloration. Pine nuts are the grosbeak's main food source. STEPHEN C. HINCH

Far right: The first light of day paints Red Eagle and Little Chief Mountain above the St. Mary River, a tributary of the Oldman River in southern Alberta, Canada. ZACK CLOTHIER

Below: Baring Creek Bridge is just one of several prominent concrete and stone structures that can be found along Going-to-the-Sun Road. Completed in 1931, the bridge was constructed using native stone to blend in with the natural landscape. Along with Baring Creek, a short hiking trail passes beneath the bridge and also leads to Baring Falls. ZACK CLOTHIER

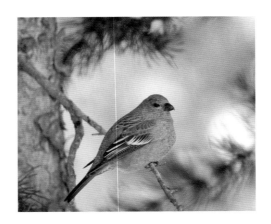

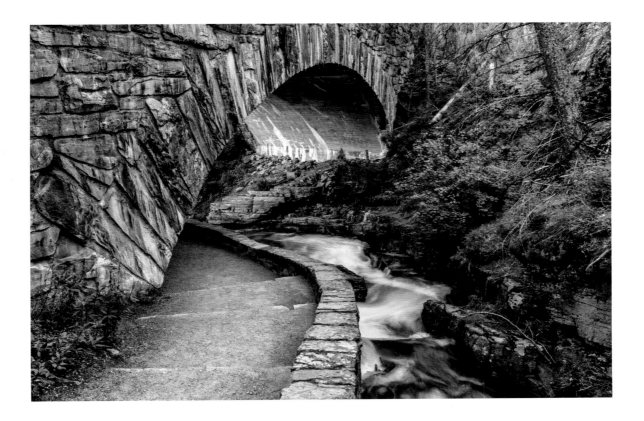

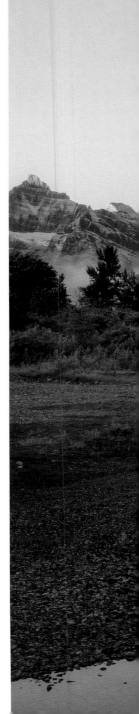

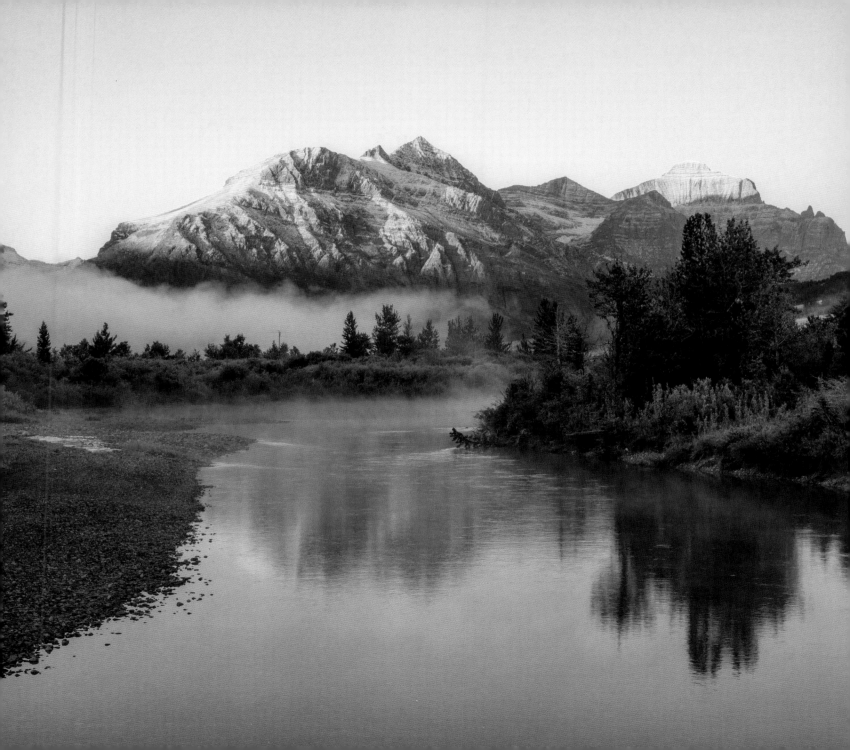

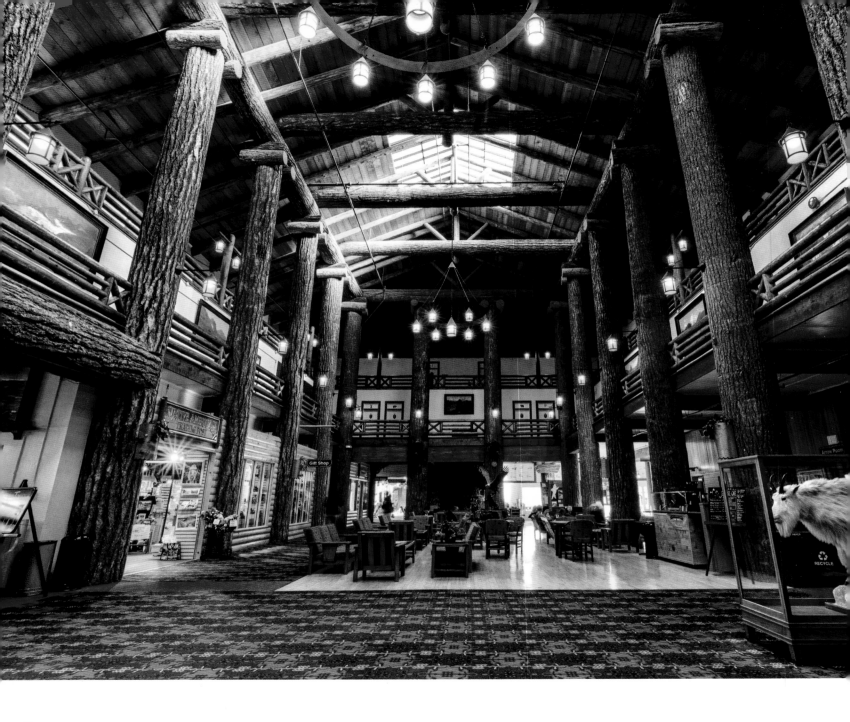

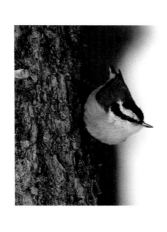

Left: Red-breasted nuthatches are among the smallest songbirds found in Glacier National Park. These diminutive birds, only about four inches in length, can be seen walking up and down pine trees looking for food in the tree bark. They primarily are found in coniferous forests of pine, spruce, fir, and cedar. STEPHEN C. HINCH

Far left: The first in a series of lodges built by the Great Northern Railway in and around Glacier National Park, the historic Glacier Park Lodge was constructed in 1912-13. The lodge sits just outside the park boundary in the small village of East Glacier Park, Montana. The East Glacier Park Amtrak station is located directly across from the hotel, providing easy access for visitors traveling by train. Inside the lodge, massive beams of Douglas fir tower over the lobby, and cozy campfire-like stone fireplaces emanate a wilderness-like ambience. ZACK CLOTHIER

Below: When the huckleberries ripen in late summer, almost every berry patch will have bears feeding in it. This grizzly bear was feeding on huckleberries near the road, allowing park visitors the opportunity to safely view it without leaving their vehicles. When wildlife is near the road, be sure to use pullouts for viewing opportunities. STEPHEN C. HINCH

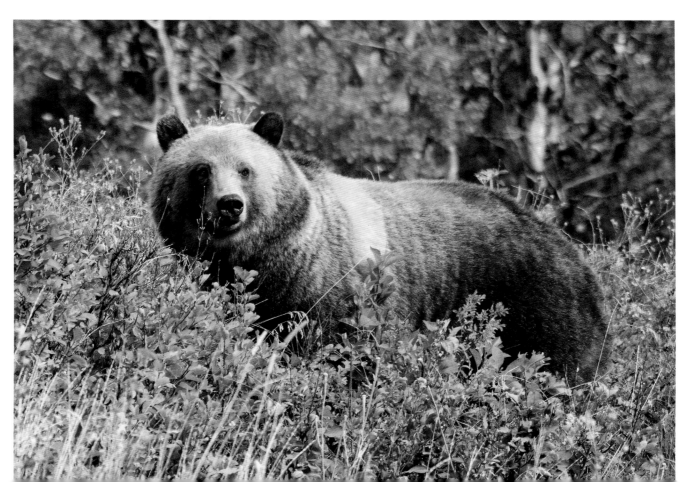

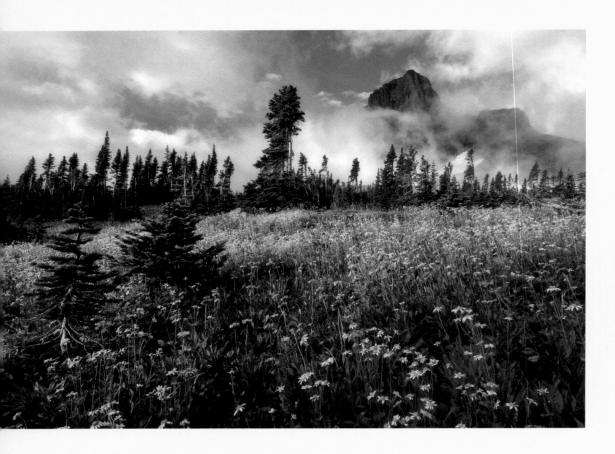

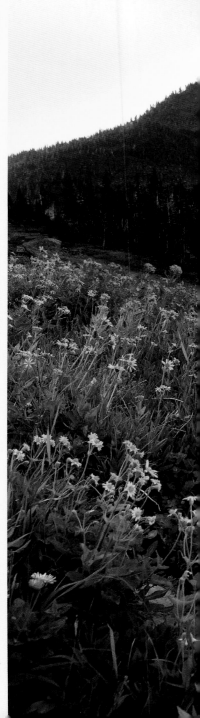

Above: Clouds clear on a summer morning, revealing Clements Mountain above a wildflower-filled meadow near Logan Pass. ZACK CLOTHIER

Right: The spruce grouse is a fairly common species of the north woods, but can be difficult to find. Spruce grouse prefer coniferous forests, and feed mostly on conifer needles, particularly spruce. ZACK CLOTHIER

Far right: Reynolds Mountain rises above Hidden Lake far below, while a meadow full of wildflowers covers the high slopes. Hidden Lake truly is hidden, as high mountains surround it on all sides. The trail to the overlook is only about 1.3 miles in length, but a steep descent leads down to the lake itself, for a tough round-trip hike of just over five miles. STEPHEN C. HINCH

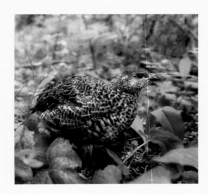

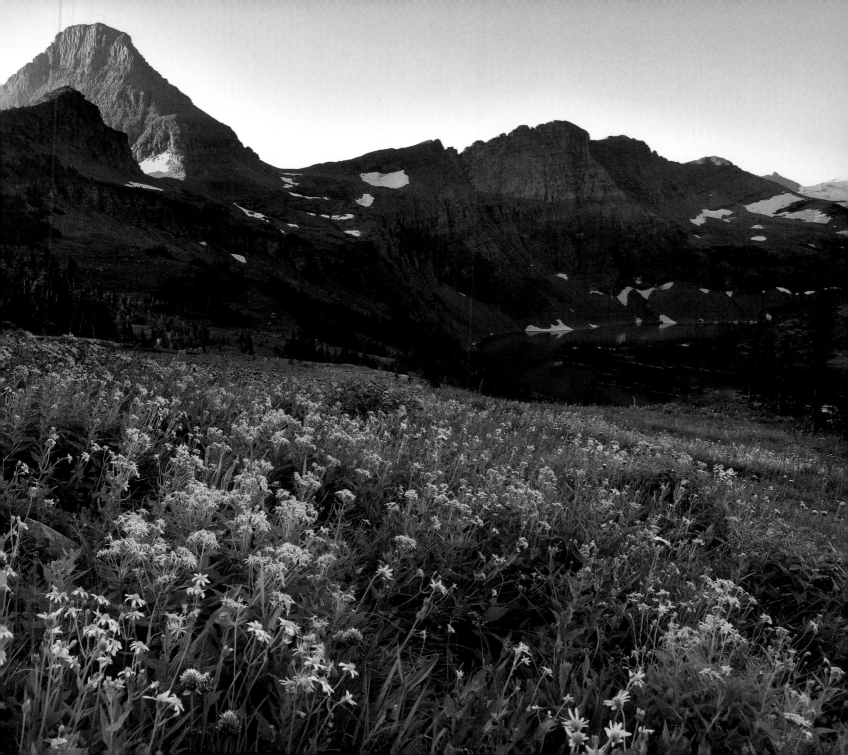

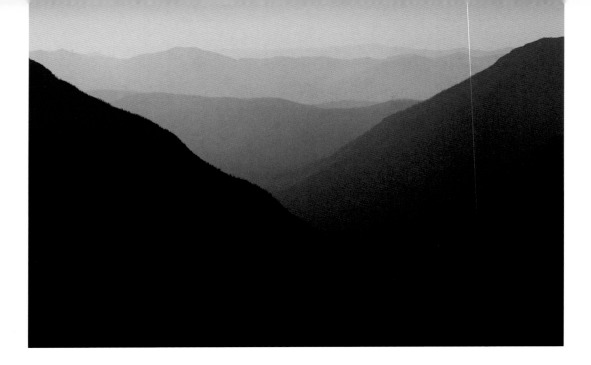

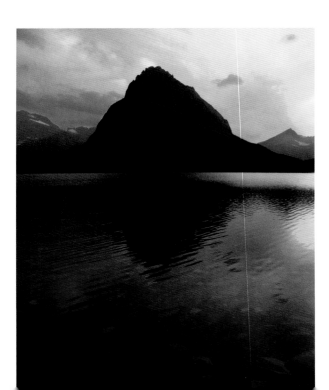

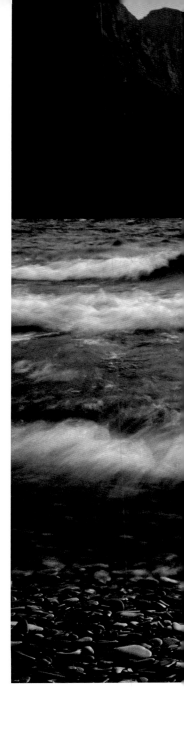

Above: Layering mountains at sunset can be seen from many locations in Glacier National Park. This scene was photographed from the Hidden Lake Overlook above Logan Pass. Each layer provides depth into a seemingly never-ending line of mountains. STEPHEN C. HINCH

Right: Grinnell Point towers approximately 2,700 feet above Swiftcurrent Lake, with near-vertical cliffs providing a dramatic scene. This photo was taken at sunset, and sunrise is equally stunning, but no matter what time of day, it's one of the most breathtaking landscapes in Glacier. STEPHEN C. HINCH

Far right: Waves batter the shore of St. Mary Lake on a very windy late summer evening. Situated in a rain shadow, the east side of the park has a much drier climate than the west side. This dryness is in part due to the strong downslope winds that occur here, often exceeding 50 mph, with occasional gusts reaching 100 mph. ZACK CLOTHIER

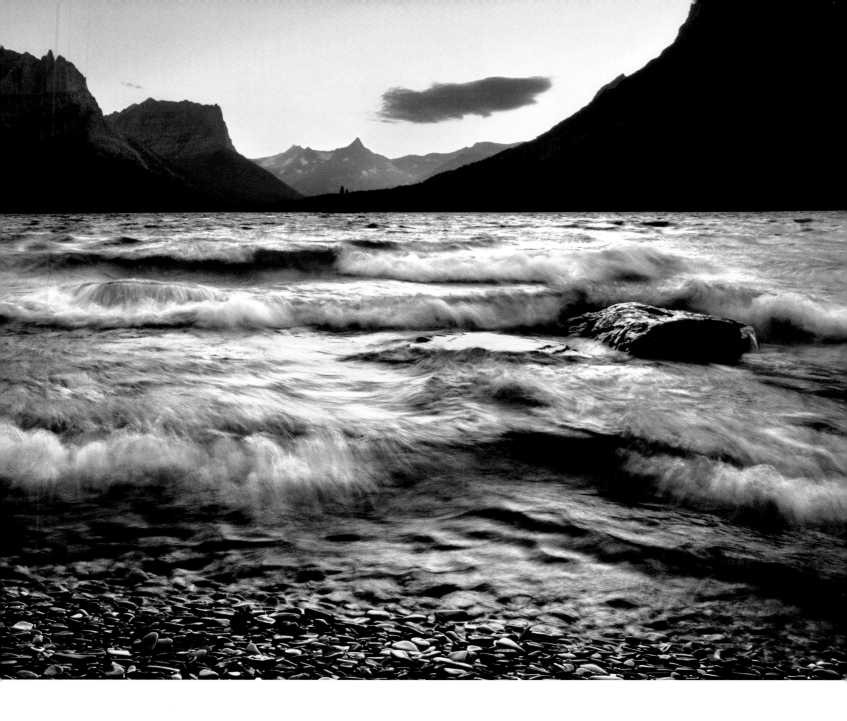

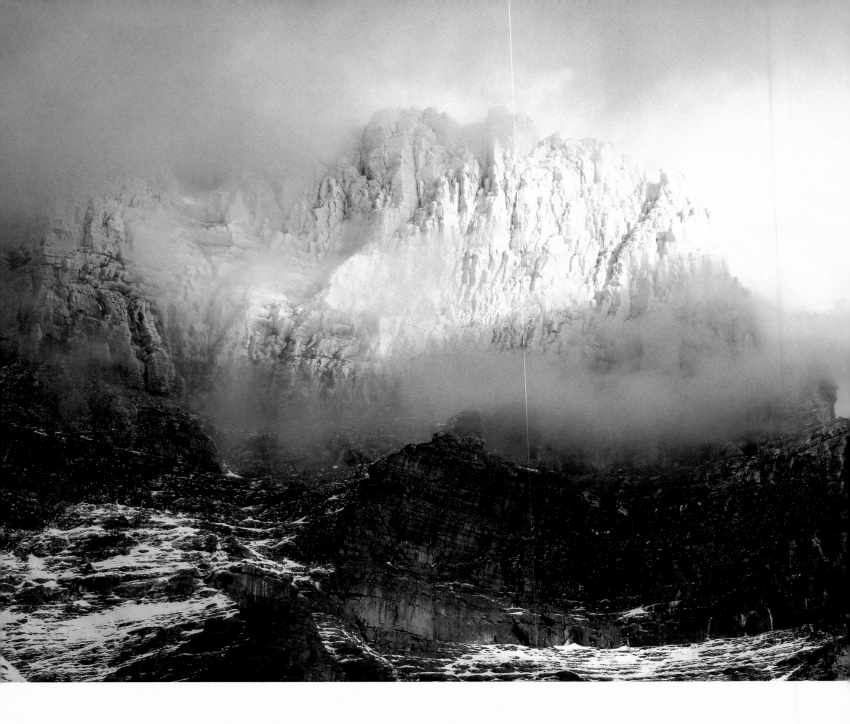

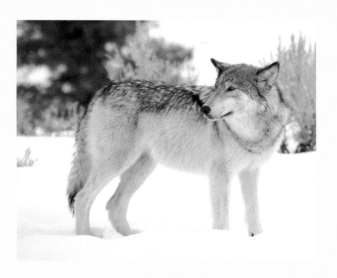

Left: It's a very lucky visitor that sees a wolf in Glacier National Park. While wolves can be found here, their secretive nature makes them difficult to spot. A lucky camper might hear the howls at night as wolves communicate to each other, but don't mistake the wolf's long, mournful howl for the yips and barks of the wolf's cousin, the coyote. STEPHEN C. HINCH

Far left: Winter arrives early in Glacier National Park. Snow can fall any time of year, but by November the park is usually receiving its blanket of snow. The Going-to-the-Sun Road is plowed each spring but usually doesn't open until late June or early July. The heavy snowpack from winter provides important moisture into the summer. STEPHEN C. HINCH

Below: A small herd of bighorn sheep lingers in front of Mount Gould in the Many Glacier Valley. During the winter months, bighorn sheep congregate at lower elevations in the park where food sources are more plentiful. ZACK CLOTHIER

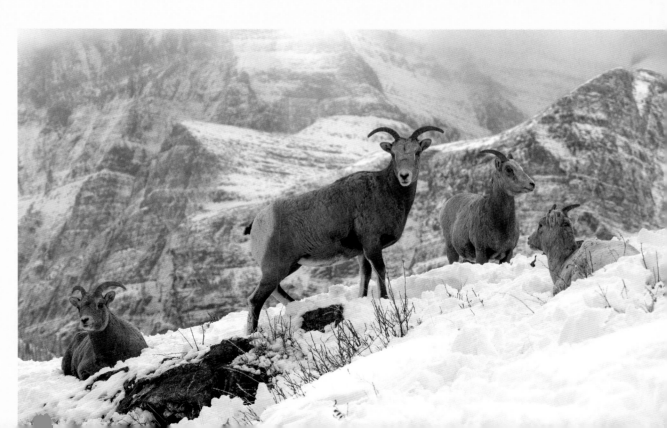

Right: Coyotes are often mistaken for wolves. But coyotes are much smaller than a wolf, and while gray wolves can vary in color from white and gray to black, coyotes are almost always a tan or beige color. Coyotes tend to be more solitary as well, though it's not uncommon to find two or more together, especially during mating season in the winter. STEPHEN C. HINCH

Far right: Built in 1914 by the Great Northern Railway, Granite Park Chalet was one of nine backcountry chalets constructed in and around Glacier at the turn of the century. Until recently, two of the original chalets remained operational. In 2017 a forest fire destroyed Sperry Chalet, leaving Granite Park Chalet as the only currently functioning chalet within the park. The rustic accommodations, however, are only available to those willing to work for them. Reaching this National Historic Landmark requires a moderate seven-mile hike on the renowned Highline Trail, which runs along the Garden Wall near Logan Pass. ZACK CLOTHIER

Below: In autumn, leaves are not the only thing to change color. The forest under-brush also transforms into brilliant reds, oranges, and yellows. This is particularly noticeable from the many hiking trails found throughout the park. ZACK CLOTHIER

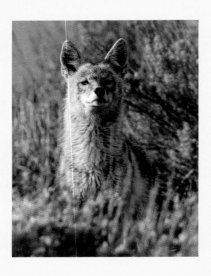

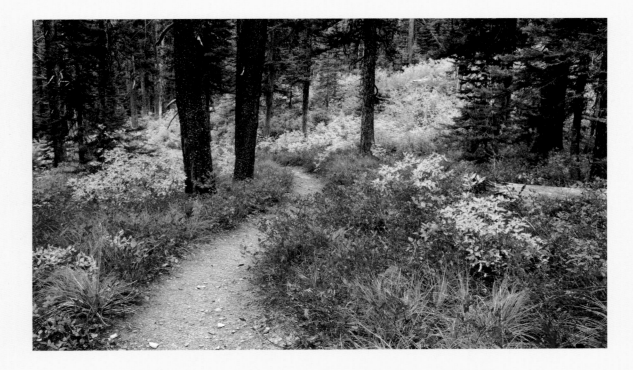

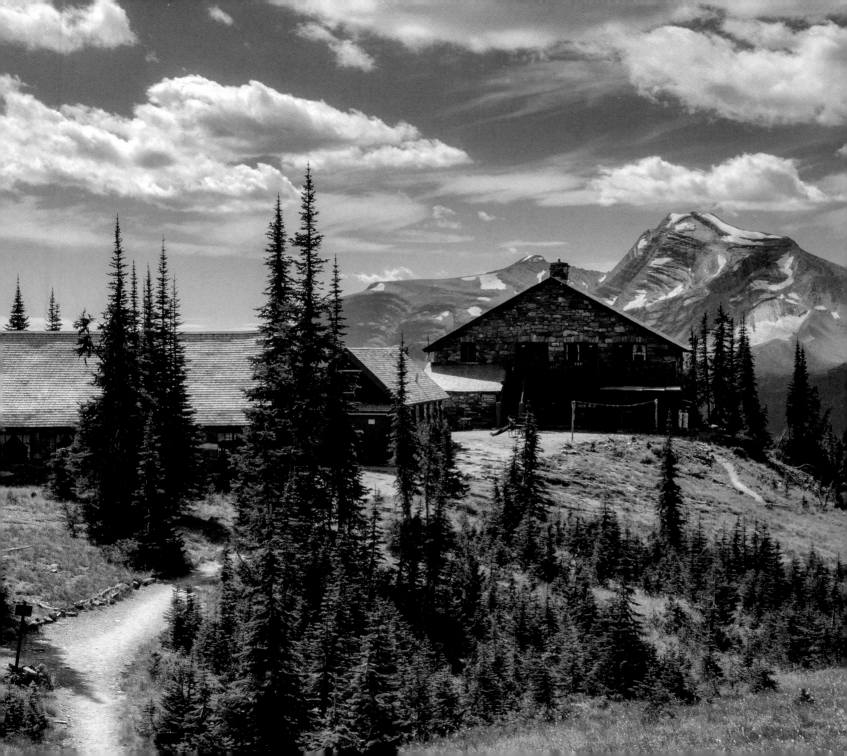

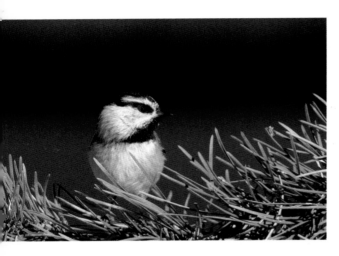

Above: Mountain chickadees are among the most common songbirds found in the northern Rockies. They prefer coniferous forests where they find their favorite foods of insects and seeds. At only about five inches long, it's not uncommon to see these avian acrobats hanging upside down on pinecones as they try to get to the seeds.
STEPHEN C. HINCH

Right: With its lakeside setting and world-class views, the Many Glacier Hotel is the largest of the grand lodges in Glacier. Built in 1914-15 by the Great Northern Railway, this Swiss chalet-style hotel contains 214 rooms. Located on the shores of Swiftcurrent Lake in the Many Glacier Valley, the hotel's secluded location offers visitors a unique lodging experience. Wildlife watching, hiking, horseback riding, and scenic boat tours are all popular activities here.
ZACK CLOTHIER

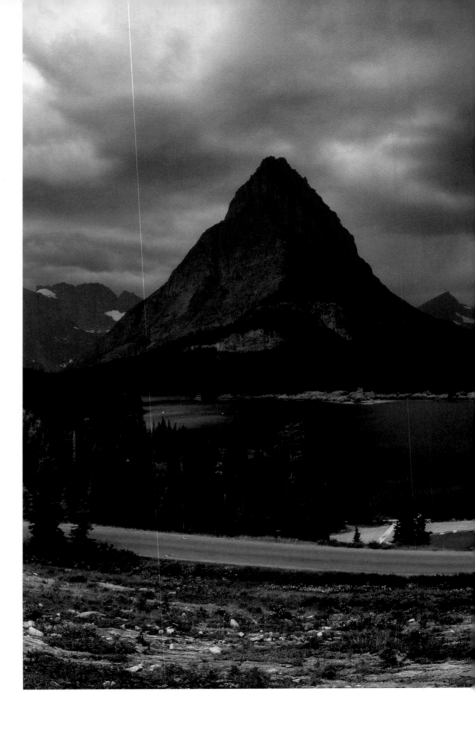

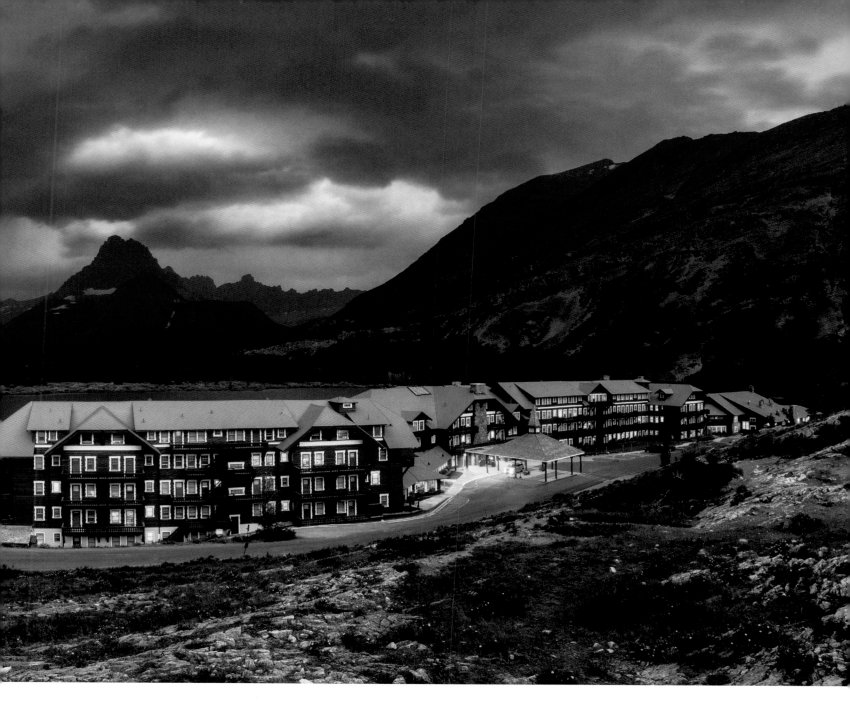

Right: The western meadowlark was named the state bird of Montana in 1931. One of the first harbingers of spring, the meadowlark's song signifies the end of winter and is a welcome sound. Western meadowlarks prefer open sage flats where they hunt insects and build ground nests under bushes or rocks. STEPHEN C. HINCH

Far right: Sherburne Peak and Yellow Mountain, both part of the Lewis Range, rise dramatically above large swaths of golden-colored aspens in the extreme northeast corner of Glacier National Park. Excellent autumn vistas can be found along the Chief Mountain Highway, also known as Montana 17, which travels from Glacier to Waterton Lakes National Park. ZACK CLOTHIER

Below: Elk are one of the largest land mammals found in North America, typically weighing 500 to 700 pounds. Each year, bull elk grow an impressive set of antlers that are used both to attract a harem and also during fierce sparring battles with other bulls during the autumn rut, which occurs from late August to December. Look for elk at the forest's edge, especially during dawn and dusk. ZACK CLOTHIER

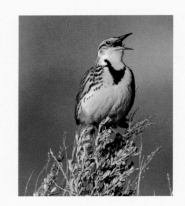

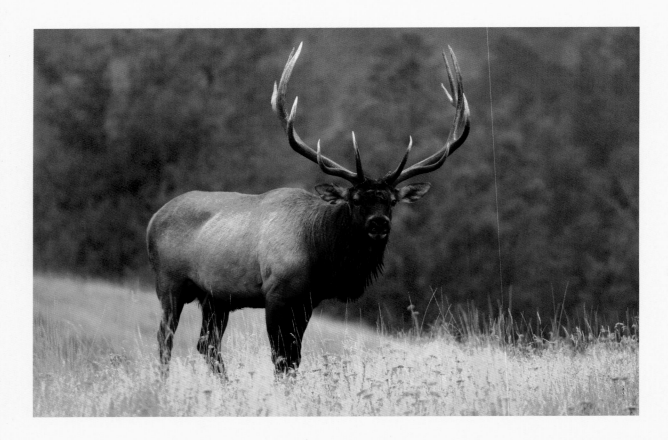

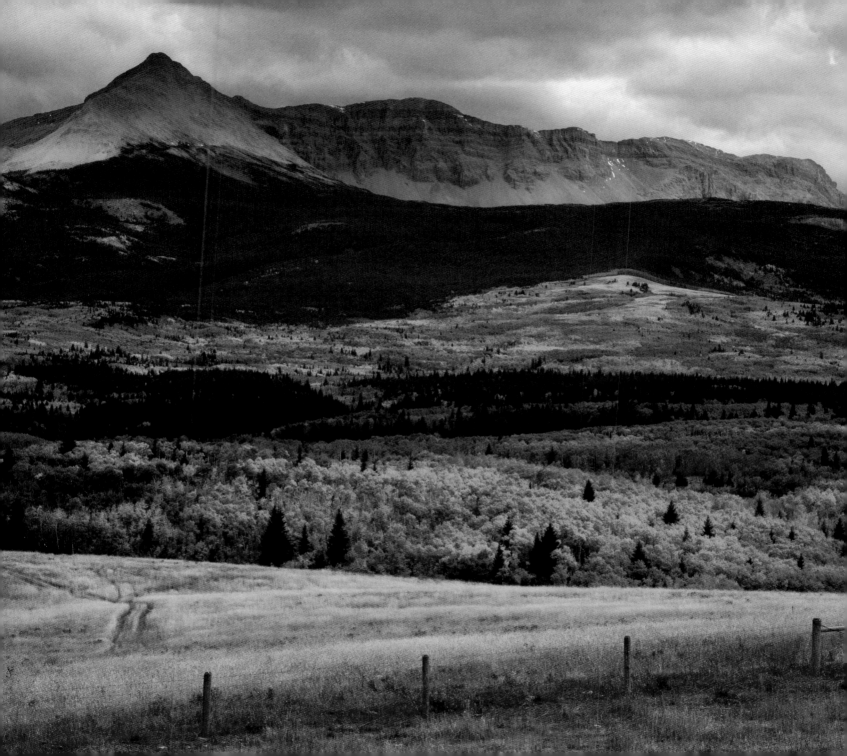

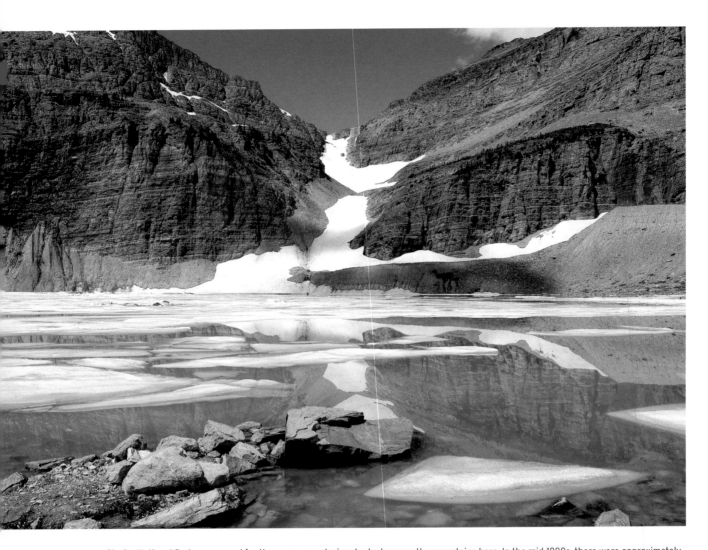

Above: Glacier National Park was named for the numerous glaciers tucked among the mountains here. In the mid-1800s, there were approximately 150 glaciers within the area that would become the national park; today there are fewer than thirty ice formations large enough to even be called a glacier. Hikers arriving at Grinnell Glacier will find a large glacial lake where ice once dominated. Grinnell Glacier lost approximately 40 percent of its acreage between 1966 and 2005, and has lost even more since then. STEPHEN C. HINCH

Right: Cracker Lake is a beautiful turquoise color due to the glacial silt flowing into the lake from the glaciers above. Mount Siyeh, at over 10,000 feet in height, and Allen Mountain, at just under 9,400 feet, rise above the lake to the left and right, respectively. Viewed here, a ridge coming off Mount Siyeh provides a dramatic background to the turquoise lake and crimson paintbrush. STEPHEN C. HINCH

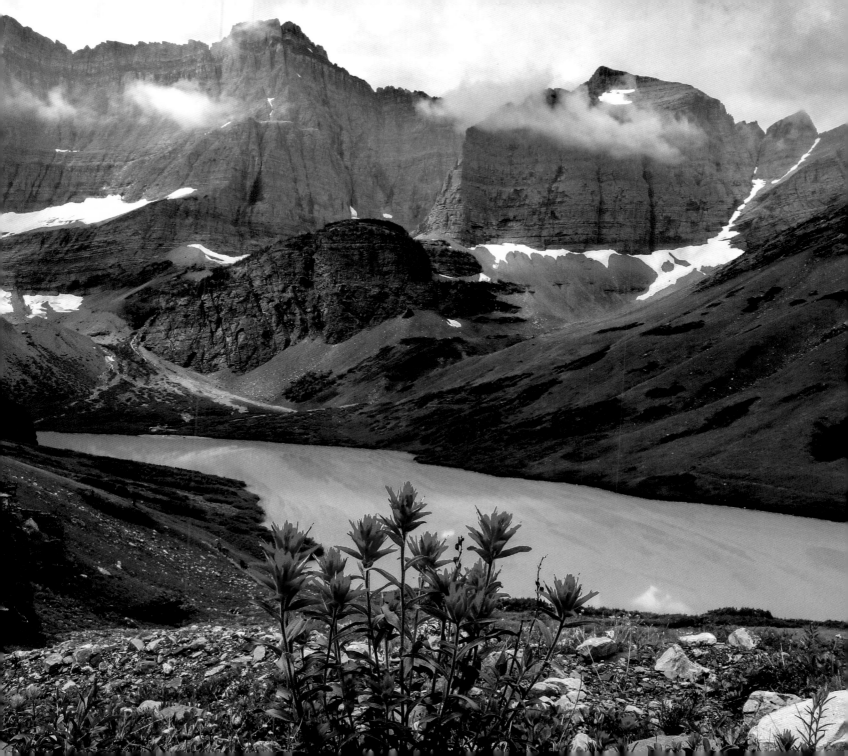

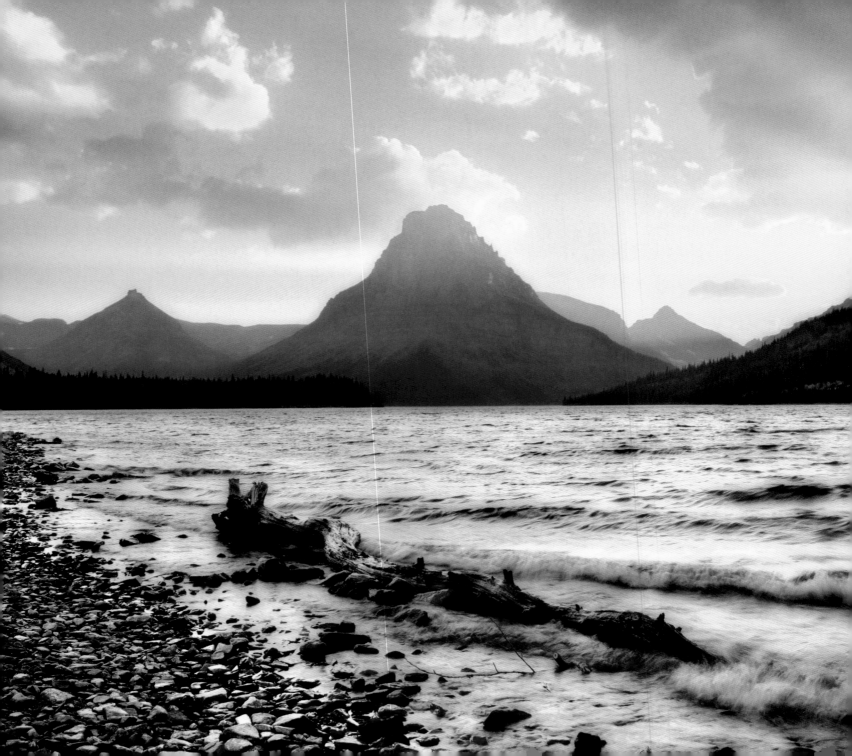

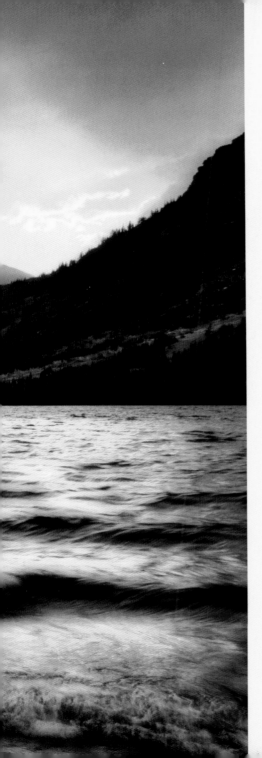

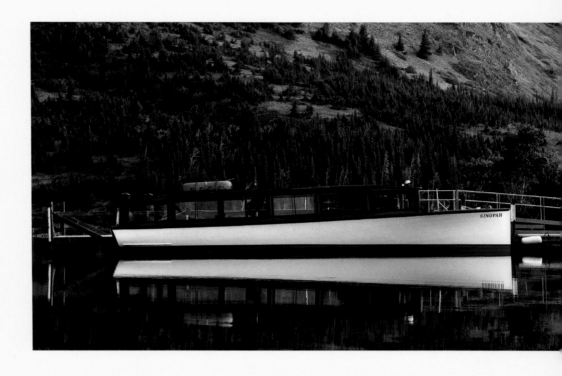

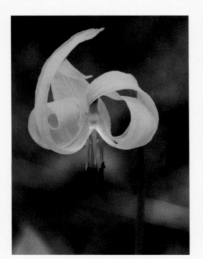

Above: The tour boat Sinopah was first built in 1926 and operated on St. Mary Lake. Originally named Little Chief, the Glacier Park Boat Company bought it in the 1940s, moved it to Two Medicine Lake, and renamed it Sinopah. The boat provides tours on Two Medicine Lake during the summer months. STEPHEN C. HINCH

Left: Glacier lilies are one of the first wildflowers of spring. They often bloom when there's still some snow on the ground and can be found at different elevations from spring into late June. The beautiful yellow flowers can cover the forest floor when conditions are right. STEPHEN C. HINCH

Far left: Sinopah Mountain is the centerpiece of the Two Medicine Valley. Part of the Lewis Range, its sheer wall of cliffs thrusting upward forms an impressive backdrop above the west end of Two Medicine Lake. ZACK CLOTHIER

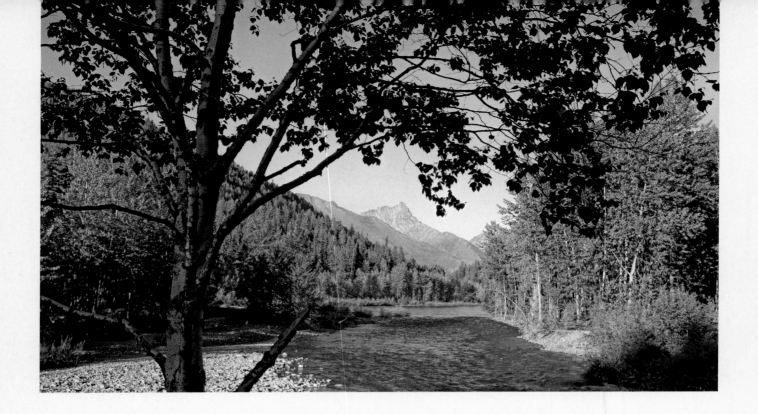

Above: The Middle Fork of the Flathead River roughly follows the southern boundary of Glacier National Park and U.S. Highway 2. While the river is popular with fly anglers, this area also provides some long hiking trails into the remote backcountry of Glacier where few people venture. The Izaak Walton Inn makes an excellent base for exploring this area, as do several national forest campgrounds just outside the park. STEPHEN C. HINCH

Right: A fly fisherman tries his luck on Kintla Lake, in the remote North Fork area. Select waters in Glacier National Park are open to fishing. Artificial lures and flies must be used to reduce the potential harm and impact to native fish. Although a fishing license is not required to fish in Glacier, be sure to stop by the nearest visitor center to pick up a copy of park regulations before venturing out on the water. ZACK CLOTHIER

Far right: Hiking is perhaps the best way to experience Glacier National Park. While the Going-to-the-Sun Road affords incredible views, Glacier's backcountry has many more. A hiker enjoys the view of Mount Gould while below, Lake Josephine is visible through the forest. Angel Wing is the peak in front of Mount Gould. STEPHEN C. HINCH

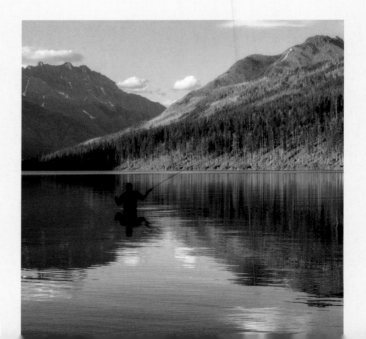

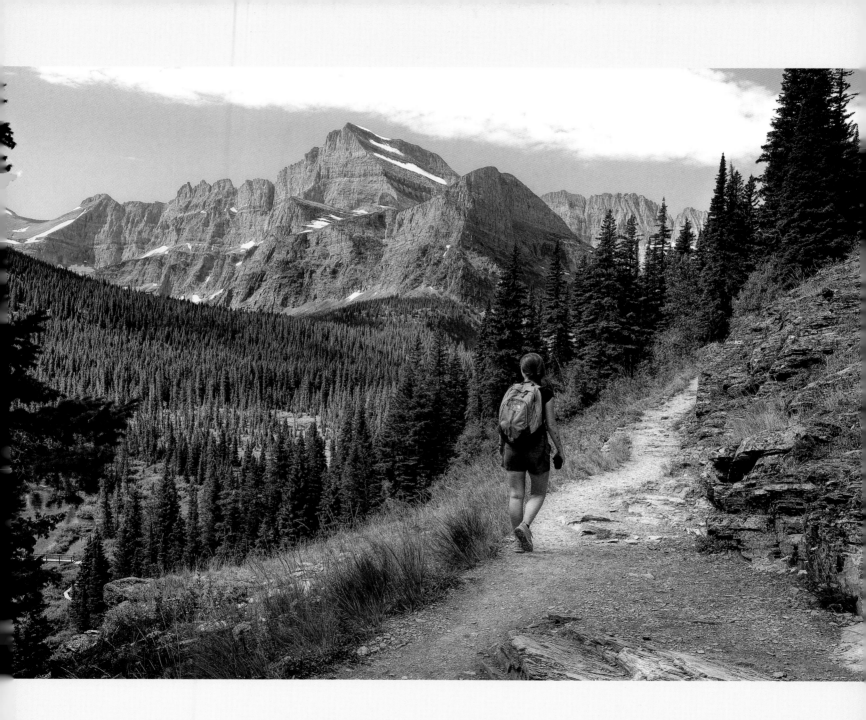

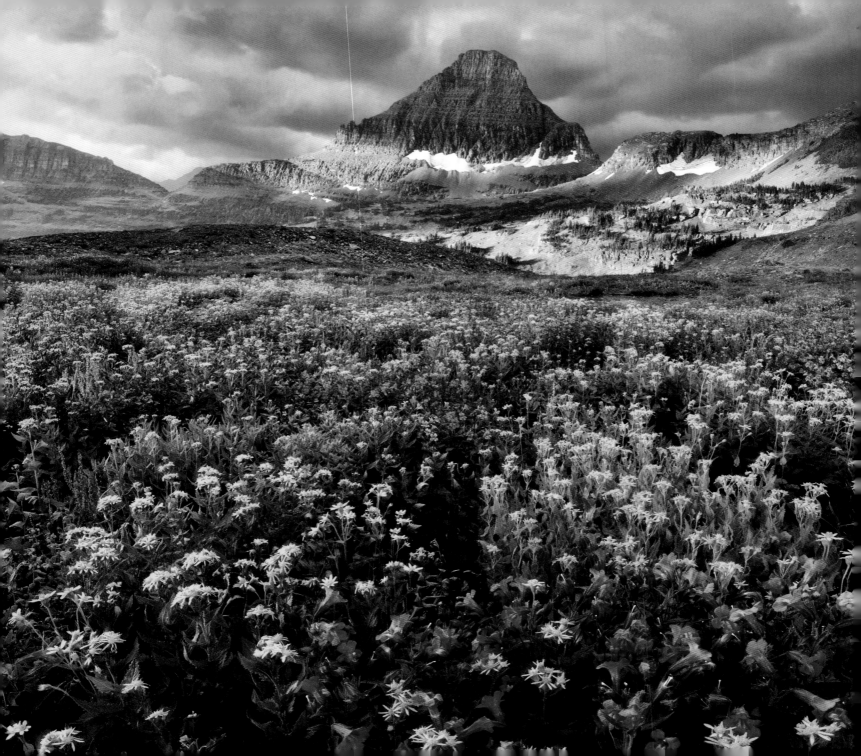

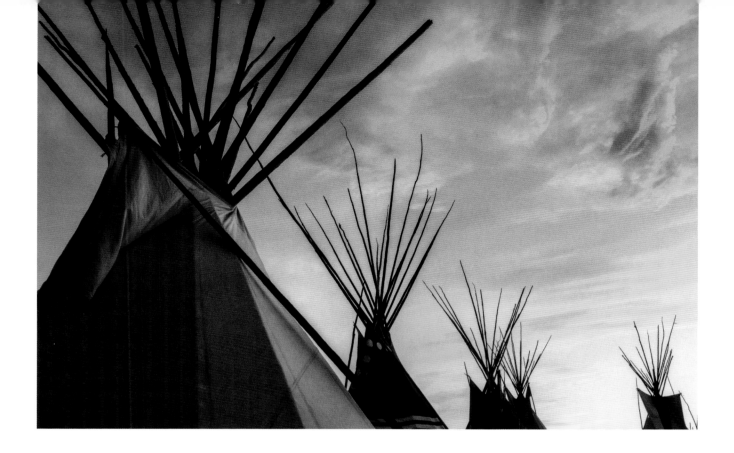

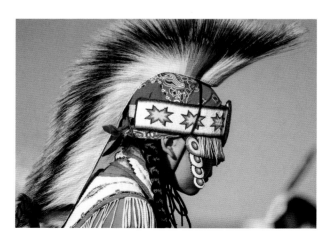

Above: Tepees line up at sunset during the annual North American Indian Days celebration in Browning each summer. Used as year-round shelters, the flaps at the top of the tepee, sometimes referred to as "smoke ears," acted as ventilation openings for the smoke from the fire burning inside the lodge. ZACK CLOTHIER

Left: A variety of Native dances, parades, and Grand Entries welcome visitors at North American Indian Days with brilliant displays of color, Native culture, and traditions. The Blackfeet Indian Reservation is bordered by Glacier National Park to the west and is one of the largest in the United States. ZACK CLOTHIER

Far left: Reynolds Mountain is lit by the first light of day above a sprawling carpet of wildflowers. Due to the extreme nature of the environment, the growing season in the alpine zone is very short. The wildflowers that grow in these harsh conditions have adapted in various ways to cope with the strong winds, cold temperatures, and occasional snow squalls that are common here. ZACK CLOTHIER

Right: St. Mary Lake from the Wild Goose Island overlook is one of the most iconic views in Glacier National Park. Sunset colors reflect in the waters of the lake while the small island sits alone, dwarfed by the mountain peaks high above. The lake has a maximum depth of approximately 300 feet, and scenic boat tours operate during the summer months. STEPHEN C. HINCH

Below: Summer wildflowers put on a show as they adorn a hillside above Lake Sherburne in the Many Glacier area of the park. Lake Sherburne is a reservoir created by the Lake Sherburne Dam, which was constructed on Swiftcurrent Creek between 1914 and 1921. STEPHEN C. HINCH

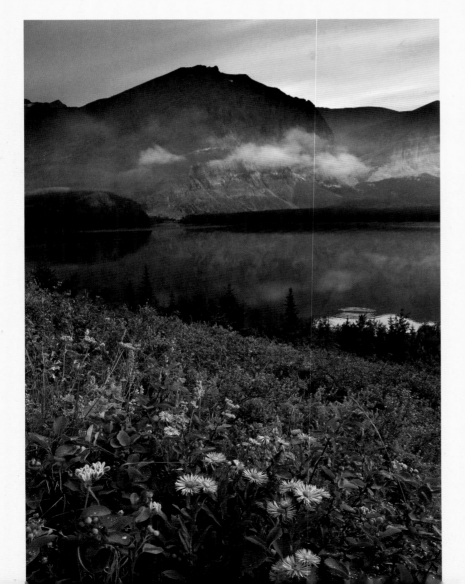

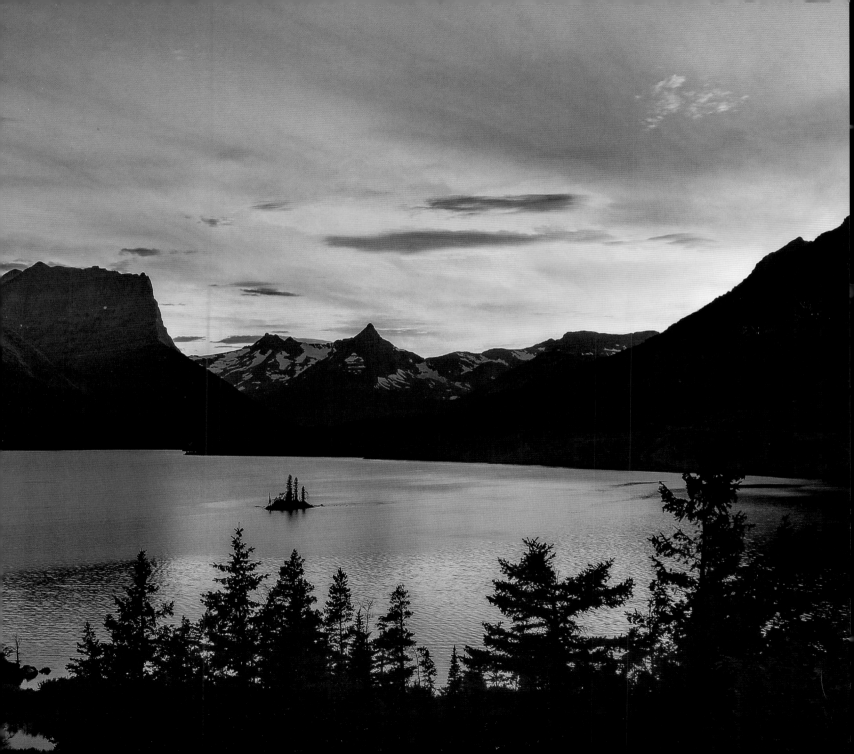

ZACK CLOTHIER

Based in the Seeley-Swan Valley in western Montana, Zack Clothier is a full-time nature photographer specializing in landscapes and wildlife of the American west. In addition, Zack is also an avid outdoorsman and skilled animal tracker. Zack's passion for nature, combined with an eye for composition, allows him to capture the beauty he finds in all things wild.

Clothier's photographs have appeared in numerous advertising campaigns, publications, and exhibitions around the world. When he's not photographing, Zack can usually be found hiking into some remote wilderness, or fly fishing on one of Montana's blue ribbon trout streams.

To see more of Zack Clothier's photography, visit www.zackclothierphotography.com.

STEPHEN C. HINCH

Award-winning photographer Steve Hinch is a full-time resident of Montana. Steve made his first trip to Glacier National Park in 2006 and fell in love with the incredible scenic beauty. Now, having photographed the crown jewel of the northern Rockies, Steve is excited to share his vision of Glacier in this book.

Through his wildlife and scenic landscape images taken across the country, Hinch shares unique views of nature as they happened in a single moment in time. Hinch's images have been featured in a variety of publications and collections, including the Smithsonian Institution National Museum of Natural History.

To see more of Steve Hinch's photography, visit www.stevehinchphotography.com.

This page: Beautiful autumn colors brighten the landscape in the Belly River region of Glacier National Park. Aspens and cottonwoods provide most of the color during the autumn leaf show, but even a conifer joins in as the larch trees turn gold in October. STEPHEN C. HINCH